# HOW TO CREATE COMICS

## From Script To Print

*by*

## Danny Fingeroth
Editor-in-chief, **Write Now! Magazine**

## Mike Manley
Editor-in-chief, **Draw! Magazine**

Photo by Sofia Negron

# HOW TO CREATE COMICS FROM SCRIPT TO PRINT

As demonstrated via the creation of THE THIEF OF TIME and "A Glitch in Time," her first adventure.

**Conceived and edited by**
DANNY FINGEROTH, Editor-in-chief, *Write Now! Magazine*
MIKE MANLEY, Editor-in-chief, *Draw! Magazine*

**Designer**
MICHAEL KRONENBERG
**Based on the original magazine
designs by** CHRIS DAY and MIKE MANLEY

**Transcriber**
STEVEN TICE

**Publisher**
JOHN MORROW

**Cover art by**
MIKE MANLEY

**Photo on page 1 by**
SOFIA NEGRON

**Proofreading by**
ERIC NOLEN-WEATHINGTON
JOHN MORROW

**Special Thanks to**
ALISON BLAIRE
JOHN MORROW
SOFIA NEGRON
ERIC NOLEN-WEATHINGTON
CHRIS POWELL
BEN REILLY
VARDA STEINHARDT

TwoMorrows Publishing
10407 Bedfordtown Drive
Raleigh, North Carolina 27614
www.twomorrows.com • e-mail:
twomorrow@aol.com

First Printing • June 2006
Printed in Canada

ISBN: 1-893905-60-8

# TABLE OF CONTENTS

Most of the material in this book originally appeared in *Write Now! Magazine #8* and *Draw! Magazine #9.* This collected version contains 35 PAGES of NEW or ENHANCED MATERIAL, which is indicated below with an asterisk (*)

# COLOR SECTION

# Foreword by

## DANNY FINGEROTH, Editor-in-chief WRITE NOW! Magazine and MIKE MANLEY, Editor-in-chief, DRAW! Magazine

**W**ell, here's something you don't see every day. It's *How to Create Comics from Script to Print*–the **expanded version** (with more than 30 NEW PAGES!) of the *Write Now! / Draw!* Crossover, all combined in one nifty package!

It all started when we decided to do a crossover between our magazines. It seemed like a natural. *Write Now!* is about writing, *Draw!'s* about art! Put 'em together (with lettering, coloring, and sundry other ingredients) and you've got comics! (Or "graphic novels," if you prefer.)

Of course, we then had to figure out what exactly such a crossover would *be*. What we came up with was the idea that we would show *step-by-step* how a new character is created, and then how her origin story came to be. And that's what we did. You hold in your hands the result of our efforts.

Essentially, we decided to show you as much as we could of–to in effect map out–the creative process. Although much of anybody's process goes on inside their heads while doing things that seem totally unrelated, we tried to keep records of memos, conversations, and e-mails, and put them together to show you how we came up with *Thief of Time.* To be honest, since so much of creative work is unruly and chaotic, just ordering the process is in itself creating a simulation of the creative process. Nonetheless, we think there's much of value that we came up with to show you here. Whether or not you like our new character (and we have a feeling you're going to go nuts for her), there's much to chew on as you follow us along the creative trail.

Now, we've co-created characters before. Together, we did 25 issues and an annual of *Darkhawk* for Marvel in the 1990s. While **Tom DeFalco** came up with the initial concept for that character, Danny fleshed him and his universe out substantially, and Mike designed the whole shebang. Significantly, as far as this book, we completely co-created any new villains and many of the supporting cast members of the *Darkhawk* series that appeared in those issues. So Savage Steel, Lodestone, Psi-Wolf, and a bunch of others were co-created by us (no doubt with input from then-editorial staffers **Howard Mackie, Nel Yomtov, Greg Wright, John Lewandowski** and **Richard Ashford**).

*Thief of Time,* though, is the first time we've created a title character together, and the first time we've worked "without a net," that is, without editorial input. Everything you see, love it or hate it,

comes from the two of us. And, of course, in this book, you get to see how the collaboration came out in the full-color finished *Thief of Time* comic story that we created! (Feel free to show it to Hollywood producers with excess cash.)

Aside from the roadmap of creation, you'll find a whole mess of important "how-to" material in this book.

- You'll learn about the nuts and bolts of writing in Danny's **mini-lessons** that comprise the *"Write Now! Comics School"* (including 7 all-new lessons prepared just for this book). The tutorials (inspired by such folks as **Dennis O'Neil, Jim Shooter, Tom DeFalco, Louise Simonson,** and the late **Hank Levy**) are designed to give you the basics about **story structure, character development, dialogue,** and other essentials of writing.

- In the **"My Process"** sections, Mike shows you how he creates a story from a script–from **sketches,** to **penciling,** to **inking, coloring,** and **lettering**.

- And you'll also find all sorts of valuable information on **how to prepare your comic for printing, how to pitch to a publisher, self-publishing,** and much more. And there's an all-new section of **resources for comics creators** that we think you'll find extremely valuable.

### DVD MANIA

If you like this book, then you won't want to miss the DVD version (with the slightly different title: "How to *DRAW* Comics from Script to Print") that will show you on screen and in detail all the things that we cover in this book–and then some! The disc features us showing and telling how we create comics–not unlike what we do in the courses we teach. The book and the DVD are perfect companion pieces to each other.

Okay, you've been extremely patient. Now it's time to let you get into the book and see for yourself: *How to Create Comics from Script to Print!*

*Danny Fingeroth*
*Mike Manley*
*May 2006*

# Making Comics

## What This Crossover is All About

**By Danny Fingeroth**
Editor-in-Chief
*Write Now!* Magazine

> "MOST OF MY 'WORK' TIME IS SPENT DAYDREAMING. I SPEND VERY LITTLE TIME AT THE KEYBOARD... DAYDREAMING IS THE JOB. MY WIFE'LL TELL YOU--I DO IT 24/7."
> --CHUCK DIXON

**A**s Mr. Dixon implies, the creative process is mysterious (though not as mysterious as some would have you believe), constant, and often unseen.

So, although the stated purpose of this issue of *Write Now!* and it's continuation in *Draw!* #9 is to show you the creative process that goes into inventing a new character and her universe, as well as into telling the first story ever told featuring her, there's a lot you won't be seeing. As a matter of fact, you'll have to draw on a lot of your own creativity to fill in the gaps.

Nonetheless, I believe that what **Mike Manley** (*Draw!*'s Editor-in-Chief) and I are giving you may be more of an inside look inside the creative process involved in comics universe and character development than anyone has ever done before.

Knowing this would be recorded for posterity, Mike and I saved notes, memos, and sketches. We recorded conversations. We saved versions of plots and scripts and character sketches. There's a lot of stuff here, stuff you should be able to learn a lot from, even if what you learn is "I'd never do it *that* way."

But bear in mind the things you won't be seeing, things such as:

• The time banging our heads against a wall when no ideas came.

• Time at the keyboard or drawing board where what's arrived at are dead ends. (Or what seem like dead ends. Those seemingly false starts and wrong turns often lead to ideas that do work, whether in the current project or in something that won't be created for another five years.)

• What Chuck Dixon refers to as "daydreaming"—the disjointed, impressionistic process of idea formation that comes while waiting on line at the supermarket or plunging a stuffed drain—or when you're nodding to your spouse as if you're actually listening to what s/he's saying.

• Conversations Mike and I didn't record—say, when sitting together at a comics convention, or when we didn't have the tape recorder on when we were on the phone.

What you will see, though, is pretty cool. Hopefully, it will make you think about what goes into creating characters and stories and will be of use in your own writing, and in appreciating the writing of others.

Since this magazine focuses on writing, I've interspersed the Thief development pieces with one-page lessons on key elements of writing. You might want to refer back and forth between the Thief creative steps and the points made in the lessons. See if you can identify the parts of the Thief material that correspond to the points made in the lessons.

While Mike and I have tried to make a coherent narrative of the creative process, bear in mind that we *have* imposed structure on it. The process is much more disjointed, stop-and-start, herky-jerky than it may seem when it's organized, after the fact, on paper. Don't feel badly if your own process seems less structured. Most people's are—including mine and Mike's. The idea is to take what you've come up with in the throes of creative inspiration and impose logic and order on it—without draining out the juice that made the idea exciting to you in the first place.

Once again, here at *Write Now!* (and at *Draw!*, too), we're venturing into uncharted waters to show you ways of looking at the creative process maybe just a little different than ways you've looked at it before. I've no doubt that, as always, the readers of both magazines will let us know how they feel about the results of our efforts. And as always, I can't wait to hear your thoughts.

Creatively yours,

*DANNY*

Danny Fingeroth

# Thief of Time: Beginnings

## Memos Between Fingeroth & Manley

**H**ere's a selection of the correspondence between Mike and Danny that got the ball rolling on Thief of Time. The e-mails pretty much tell their own story.

### How It All Started

**10/1/02**

Mike:

Not sure how... but there's got to be a way to do a "crossover" between *Draw!* and *Write Now!*, don't ya think? Any interest?

—Danny

**11/22/02**

Mike:

As I mentioned in an e-mail last month: Any interest in doing a *Draw!-Write Now!* "crossover"? What would that mean? Maybe we could print a script in *WN* and then have it drawn in *Draw!*? Or an interview with a writer/artist or writer-artist team that starts in one mag and ends in the other. Or something actually clever!

—Danny

### The Ground Rules

**6/3/03**

Mike:

Here's my understanding of our conversation about the *Write Now!/Draw!* crossover that we had today:

We do a 6- or 7-page story, with cover a total of 8 pages.

- Premise, character and setting descriptions, character sketches and setting sketches in *Write Now!*

- Then we have a taped conversation about the characters and story, which we transcribe and put part in *Write Now!*, part in *Draw!*.

- We have a short plot outline in *WN*.

- Also in *WN*, we have some of the Plot & Script, and maybe some thumbnails of the story.

- In *Draw!*, we'd show some of the plot and script. (Maybe we do the first few pages in "Marvel style," the last few as "full-script.")

- In *WN* we'd have some of the lettered, uninked pages and some inked pages.

- In *Draw!*, we'd have more of the lettered, uninked pages, and the rest of the inked pages.

- And then... the *Draw!* color section could be the complete story, with a cover!

And we can then, hopefully, take whatever character(s) we come up with—which we'd share copyright on—and pitch them to publishers, using the 8-page insert as our sample. (So we should have a bunch more printed than we need for the insert in *Draw!*.)

Let me know what you think. Once we get a basic format we're happy with, we can present it to John and see what he thinks.

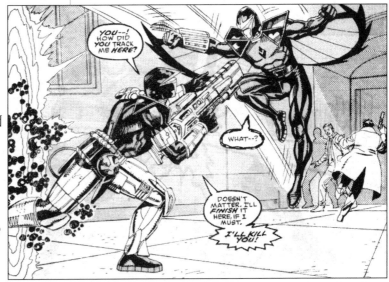

From an earlier Danny Fingeroth/Mike Manley collaboration: Darkhawk! This confrontation from *Darkhawk* #5, featuring the character Portal, has words by Fingeroth, pencils by Manley, and inks by Ricardo Villagran. [©2006 Marvel Characters, Inc.]

# Brainstorming
## 6/10/03

Mike:

Here are a couple of ideas I've been toying with for a while. Maybe one could be the crossover/pitch comic we do for *Write Now!* & *Draw!*:

One's about a master cat burglar who, when caught by the feds, becomes an agent on their behalf. It's called "License to Steal." I'd be open to the lead being female, too, or having a female partner. It would be a sort of Modesty Blaise thing, but we'd give him/her/them some cool super-gizmos.

Also was thinking of something about a time-travelling private eye, whose cases would take him back and forth in time. Working title: "Time Detective."

Either one sound interesting?

—Danny

## 1/14/04

Danny:

Why not combine them! What would every jewel thief really love to be able to do? Time travel and steal the great treasures of history. To be able to raid King Tut's tomb, the treasures of the rich and great kings of history, the zillions of great treasures lost to the past.

(I think it should be a gal character. She's gonna be more popular with the fans.)

Now to put some spin on the character interesting, maybe she isn't all bad. Maybe she helps solve crimes, but feels her compensation is heisting the treasures. Sorta' Indian Jen/crossed with Catwoman.

Either idea on its own has been really played out. But maybe we need to complicate the time travel. Make it conditional. The time-jump device might only be used at certain times of day—it could be her father's device. Maybe he is kidnapped and she must steal to keep him alive. Maybe she was a spoiled daughter who must learn to put others first. Could she have a kid sister? You get mobsters, cops, all chasing her.

Involve the cops, or government, who are also interested in the device for obvious reasons. The "man servant"—or Race Bannon, Willie Garvin character—could help her, but if he's the cop who falls in love with her, who maybe originally wanted to capture her, we get some romance too. Make it a cat-and-mouse through time.

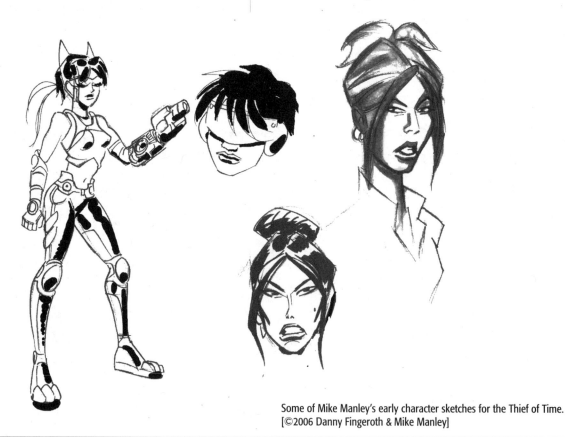

Some of Mike Manley's early character sketches for the Thief of Time.
[©2006 Danny Fingeroth & Mike Manley]

Sure a lot to cram into a little space, but the set-up could be good and that'll give you a lot to explore in *Write Now!*.

Your thoughts...?

—Mike

## Detail Work

### 1/16/04

Mike:

I love the female time-travelling master-thief idea. I'd rather not have her be daddy's girl—isn't that the backstory of every female thief in comics and TV?—but we can work that out.

There's at least one movie—*TimeCop*—that deals with a similar motif. And of course ALL THE TERMINATOR MOVIES! But we may have come up with a unique angle.

Right now, our prime need is a look for the character so I can have an inked and colored cover to John in a few weeks. I see her as high-tech but sexy. Jennifer Garner from *Alias* meets Venom meets nanotech. Maybe the time travel device can be some kind of belt she wears, but one that depends on being wirelessly connected to a larger complex of technology. Maybe the tech's something she sneaks access to—it's at a highly guarded think-tank or even in another dimension.

For the cover, I'm thinking that we see her stepping "across time" somehow. Maybe half of her is in NYC circa 2006, while the other half of her is stepping into the Wild West? Ancient Egypt? A pirate ship? (Or will that be passe soon?)

(Among other things, we'll have to determine if she can cross space as well as time. In other words, would she have to fly to modern Rome to go back to ancient Rome? I'd say that's too big a pain. Nobody ever questioned Peabody & Sherman moving through space as well as time. But it could also be an interesting story element, I suppose. For the cover, though, I think we can take whatever license we want.)

—Danny

## Technical Question

### 3/27/04

Mike:

Full-script or Marvel style?

—Danny

## Ironing Out Glitches

*These final two e-mails were written after Danny's initial versions of Thief's backstory and debut plot (both seen elsewhere in the crossover) were done.*

### 4/1/04

Danny:

Okay, we have a lot to cover here. We have a mom who's conned by a greedy husband. Does he con her waiting till she'd completed the device, knowing he'd steal it and kill her? With time travel how do we prevent her from going back and preventing the break up? Death, etc.? We have to make it so that her altering the timeline would lead to her own death or some tricky penalizing situation.

This may be just too complicated to squeeze into 8 pages here.

—Mike

### 4/1/04

Mike:

I didn't think we'd show the entire origin. Maybe just a panel or two, have her talk/think about the rest.

Might be better if the "fatal mistake" the father made was done accidentally, trying to save his wife or his fatally ill infant daughter. So he'd be a good guy, not a creep.

Maybe dad's "lost in the timestream" so she keeps following clues to where she thinks he might be, hence the need to constantly travel through time.

[Time travel stories are always full of logic holes. The idea is to just accept the logic we establish and go with it and make it as fun as we can.]

So maybe she manipulates markets and uses the dough to finance her search for her dad. Maybe the things she steals are tech or magic (or things she hopes are magic) items to further the search.

The partner? I think she does need someone to talk to and to ground her psychologically and so she herself doesn't get lost in time. And an under the surface chemistry between them would be great in a Scully/Mulder manner.

This work any better for you? Let's talk later or tomorrow a.m.

—Danny

# Thief of Time: Character Description and Design

**H**ere's Danny's character description, based on his and Mike's ideas and input. After reading it, Mike added a comment (in the middle) for them to discuss.

Mike: We won't, of course, be revealing all of her backstory in the crossover story. We'll only reveal as much as we need for the story to work.

—Danny

- 28 years old

- Professor of literature at Columbia University (so lives in NYC area)

- Olympic level athlete

- Mensa

- Checkered love life:

  - Always falls for guys who embody one or the other of her passions–the mind or the body. Never been able to find anyone who embodies both.

- **With her (fraternal, naturally) twin brother,** she has devoted her life to finding their father, lost in the time stream.

  - Parents (Nick and Nora Branscome) were scientists working on dimensional/time travel.

  - Never really believed they could do it. Just theoretical.

  - They were shocked to discover they actually could travel through time. (Was it their skill or luck that did the trick—or someone else enabling it, someone with a nefarious agenda?)

  - Nick and Nora did some exploration through time, thought it was "easy."

  - Used GPS satellite bullsh*t technology to travel in space as well as time.

*Mike's comment:*

*You would not need a jet if you can travel in time, you'd just punch in the coordinates and you'd pop into*

the past in the spot the Earth would be at the specific date and time. The device would have to have some global positioning system to be able to grid you in the proper place, tilt of the Earth, etc. [To get BACK to the present, your "anchorman" would have to control the GPS from this end?]

- Heather and her brother Henry were opposites. He was the science nerd. She loved literature and adventure. She traveled a lot.

- Without him, she'd have a hard time doing this.

- Henry *theorized* they could find their dad in timestream, but thinks it foolish for her to try. She refuses to give up on finding dad (and mom?). He helps her so she'll have at least some chance of success. Also, he refuses to let outsiders have the tech. **It stays in the family.** Would he sacrifice his sister to protect the technology? Even he doesn't know what he would do in a case like that. He just knows he doesn't want the end of the world known as "Branscome's Folly."

  - Their mother either (a) died when they were young

    OR

    - (b) was hurt in the same accident that sent their dad into time. She's in a coma. Or perhaps she was sent to a different part of the timestream.

  - Hmmm. Dad sent to the past, mother sent to the future?

As we discussed, Heather has come close to her father, but each time she did, he was seemingly killed. But then a clue would appear telling her he was somewhere in time.

## THE REASON SHE DOES WHAT SHE DOES:

To find her father and bring him safely to his home time.

The tech he developed keeps him jumping in time. HE CANNOT STAY IN ONE TIME FOR MORE THAN A FEW MINUTES. If she can get to him with tech her brother has developed, then maybe she can stabilize him in time and keep him in one time-place, hopefully her present.

**THE END**

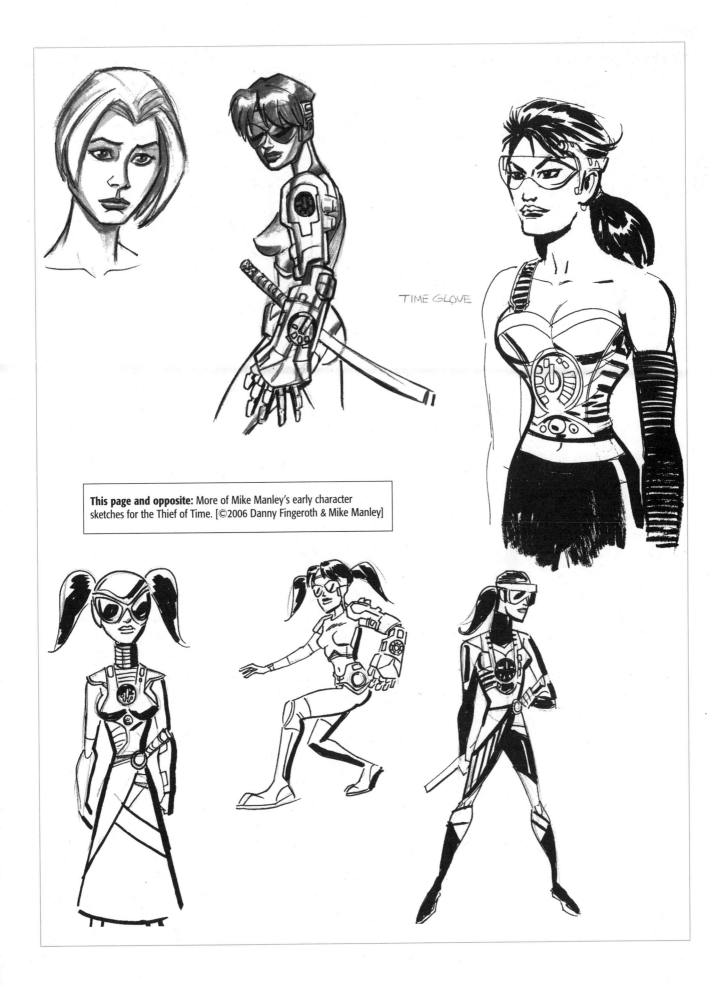

TIME GLOVE

**This page and opposite:** More of Mike Manley's early character sketches for the Thief of Time. [©2006 Danny Fingeroth & Mike Manley]

# Thief of Time: Story Outline

L ess than a plot, a story outline (sometimes called a "beat sheet"), gives the basic skeleton of a story. In this case, based on conversations and e-mails back and forth between Danny and Mike, Danny wrote up a document to make sure he and Mike were in basic agreement on the shape of Thief of Time's premiere story.

Some out-of-costume character sketches of Heather Branscome.
[©2006 Danny Fingeroth & Mike Manley]

## A GLITCH IN TIME

**PAGE ONE:**

• FULL PAGE SPLASH. Ancient Greece, the Parthenon. Heather Branscome, dressed in her adventure duds, is reaching for a beautiful URN that is on a pedestal. From the décor, it's unclear if she's in the past or in a museum. HB is clearly a 2006 woman. She makes some wisecrack about the Internet or TiVo, to make that point.

**PAGE TWO:**

• As she's about to grasp it, she is ordered to stop—

—and whirls to find herself surrounded by a dozen Greek soldiers. (Yeah, I'll get ref on all this stuff.) She laughs at them and reaches for a dial on her suit, but a quick-thinking guard has knocked her hand with his shield (or something better) and the time-dial is knocked off its setting.

She grabs the urn and, clutching it to her bosom, she turns the switch, anyway, is gone in a flash (or into the time tunnel you have on the cover).

**PAGE THREE:**

In another flash, she's still in the Parthenon, but suddenly bullets whiz by her. She's in the middle of a WWII battle.

(Or she could end up chased by dinosaurs in a prehistoric setting.)

As Nazis advance on her, she sets the dial again, and disappears—still holding the urn—as a grenade explodes where she was standing.

**PAGE FOUR:**

Heather appears (whatever effect) inside her headquarters lab.

She's greeted by Henry, her fraternal twin brother. He's standing by banks of machinery, much of it digital, many computer screens. He sees that something went awry in the timestream.

She tells him of the soldier who made her do a panic-jump to a really bad place. But she has the urn.

He takes it and runs a scanning device over it. "Dad was there, all right," he says. "He left this message."

"Let me guess," she says. "Stop looking for me. It can only result in the end of the world."

**PAGE FIVE:**

Maybe he's right, Henry speculates.

You don't believe that—or else you wouldn't be helping me try to find him, she retorts.

If I don't, you'd just find somebody else—who wouldn't care so much.

He's dead, kid. Move on.

He's lost in time, Henry. That's not the same as dead. Not when we have the tech he invented. We can save him with it.

Or we can take his death—that's what—and learn from it. You got so close to him, and just watched him die another way.

As they chat and work, a figure watches them in the shadows.

## PAGE SIX:

It's a "hitchhiker" from the trip (a ninja, or samurai, probably).

He drops from his perch and demands the artifact back.

"Where you going to take it?" she taunts him.

He advances, wrecking the lab.

"Get him out of here, Heather!"

She sets the dial.

He smashes the urn. Sh*t. They needed it.

## PAGE SEVEN:

She grabs him, starts to set the dial.

He breaks free, they explode onto Fifth Avenue in rush hour.

Battle with bystanders freaking out.

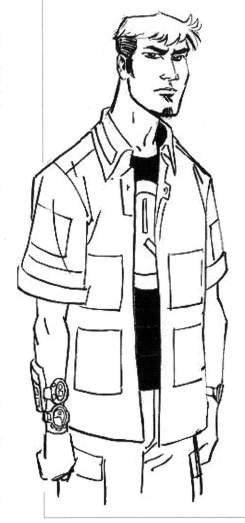

**Above and bottom left:** Early sketches for the brother character, Henry Branscome. [©2006 Danny Fingeroth & Mike Manley]

Tourists think it's a movie shoot. Snap pictures. "Bruce Willis! Bruce Willis!"

She pushes the buttons and she and he zoom through the portal.

## PAGE EIGHT:

As they go, he grabs the device from her. It clatters to the street and is crushed by a car.

They emerge in his time (ancient Japan?) and she is surrounded by ninja, with no hope of returning to the present.

But since it looks like she's going to die here—what difference can it make?

And is that her father she sees in the distance… or a near-death hallucination?

And that, of course, is our…

## CLIFFHANGER ENDING! TO BE CONTINUED...

*What you've just read is not the first outline. It went through a few versions to get to this one, with Mike and Danny deciding on changes to be made along the way. In a few pages, you'll see the actual plot that came from this outline. You'll notice it's different in several ways from the outline, starting with the length of the story.*

# Thief of Time: Plot

**W**hat follows is the "final" plot that Danny sent to Mike to draw. There were several versions leading up to this, as Mike and Danny discussed the story, leading to this plot, which Mike would do the art from. It was understood by both creators that Mike would be free to modify the story as he drew it.

The story is done "Marvel style" (see Scripting Styles lesson elsewhere in the crossover), which means that the artist works from plot instead of from a script that is broken down into panels with dialogue pre-written.

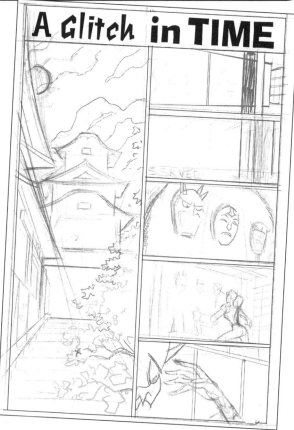

An early pencil rough of the first page of the Thief of Time story. Notice how it differs from the plot and from what the actual page (seen on page 22 of this book) turned out to be.
[©2006 Danny Fingeroth & Mike Manley]

## "A GLITCH IN TIME"

### PAGE ONE:

* FULL PAGE SPLASH. Ancient Japan. *(Is there a famous building associated with Japanese history? Something out of **Shogun** or*

something like that? Something we can do the same trick with– where we're not sure at first if she's in the past or present?)

* If we're using a mask, THAT should be the focus of the splash: A big, impressive mask being reached for by a gloved hand.

* *(MIKE: What era is your mask ref from? Where would such a mask be? A temple? A palace?)*

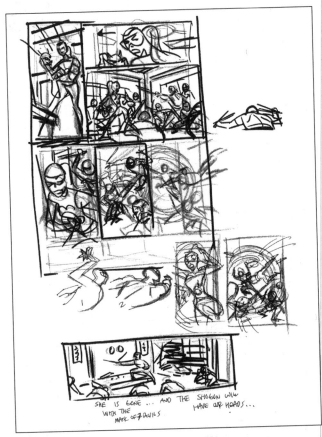

Mike's early thumbnail roughs for page two of the story. Notice how, in his thumbnails, he works out different visual ideas to express the same plot points. From there, he picks out the best ones to use. [©2006 Fingeroth & Manley]

### PAGE TWO:

* **Heather Branscome**, dressed in her adventure duds, reaches for a beautiful (JADE?) **Japanese mask** on a pedestal. From the décor, it's unclear if she's in the past or in present. HB is clearly a 2006 woman. She makes some wisecrack about the Internet or TiVo to make that point. Heather smiles expectantly. She's been after this thing for, oh, it seems like centuries.

* *Note to Mike re her wisecracks: One of the reasons Spider-Man*

*wisecracks is to relieve the tension of death-defying moments. Same with her. I'm modeling her on Jennifer Garner in* **Alias**. *Not a comedian, but never without a wry quip, either.*

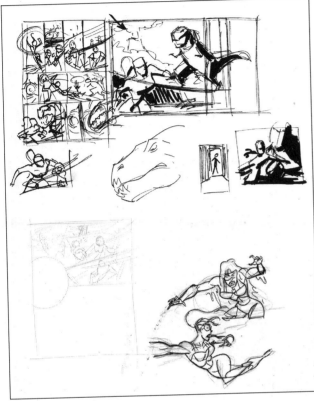

Mike working out ideas on paper for pages 1 and 3.
[right] Another version of page 3. [©2006 Danny Fingeroth & Mike Manley]

- As she's about to grasp the mask, she is ordered to stop—

- —and whirls to find herself surrounded by a dozen ancient Japanese soldiers. (Mike: Samurai? Ninjas? My Japanese history sucks.) She laughs at them—she's not here to fight, she's here to steal!—and reaches for a dial on her suit to make a quick getaway.

- But the guards attack, and she is dodging arrows and throwing stars, one of which hits the control and the time-dial is knocked off its setting.

- She grabs the mask and, clutching it to her bosom, she turns the switch on her costume anyway, and is gone in a flash (or into the time whirlpool you established on the cover). She has no idea when she's going, but it's got to be better than this!

### PAGE THREE:

- In another flash (or time-whirlpool effect), she's still in the temple or palace, but suddenly **bullets** whiz by her. She's in the middle of a pitched WWII battle.

- (Or she could end up chased by dinosaurs in a prehistoric setting.) *(MIKE: I like both of these. What do you prefer drawing?) (Both are okay with me if you can fit them in.)*

- As Japanese soldiers (or dinosaurs) advance on her, she sets the dial again, and disappears—still holding the mask—as a grenade explodes where she was standing. (Or a dinosaur stomps the rock she was standing on, shattering it.)

### PAGE FOUR:

- Heather appears inside her 2006 headquarters lab. It's a violent re-entry that sends ripples through the air and knocks stuff over and about in the lab, like someone opened a huge window in the middle of a hurricane. She's stressed from too long in the timestream.

- As the atmosphere settles back to normal, **Henry**, her **fraternal**

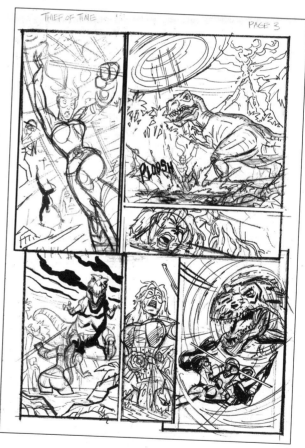

**twin** brother, comes running up to her with a blanket, which he wraps around her shoulders. They're standing by banks of machinery, much of it digital, many computer screens. Henry sees that something went awry in the timestream. *(He looks related to her, of course, but definitely is more intense, with a gaze that won't let you go if he locks eyes with you. He's, temperamentally, Q to her James Bond. Brilliant technician and scientist, but not best-suited to field-ops.)*

- She tells him of the soldier who made her do a panic-jump to a really bad place. But she has the mask. He takes it and runs a scanning device over it. "Dad was there, all right," he says. "He left a message."

- "Let me guess," she says. "Stop looking for me. It can only result in the end of the world."

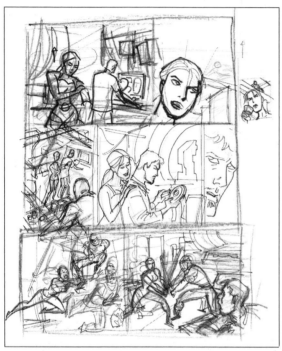

A preliminary version of page 5. Compare it to the version that saw print (shown elsewhere in this book) and note the differences—some subtle, some large—between the two.
[©2006 Danny Fingeroth & Mike Manley]

- "Maybe he's right," Henry speculates. "You don't believe that," she snaps, "or you wouldn't be helping me try to find him." "If I don't," he replies, "you'd just find somebody else—who wouldn't care so much. He's dead, kid. Move on."

## PAGE FIVE:

- "He's lost in time, Henry. That's not the same as dead. Not when we have the tech he invented. We can save him with it. Your genius can track him through time. And I have the skill to search out the clues and bring him home."

- Henry: "We made a bad mistake in time once. Would you want to risk that again—with potentially earth-shattering consequences?"

- "That's why I need you, Henry. To make sure… that never happens again. We can do it together, Henry. We have to. Don't give up on me… don't give up on *dad*." As they chat and work, a figure watches them from the shadows on a catwalk above them.

- It's a "hitchhiker" from the trip (a ninja, or samurai). He was

unconscious until a few seconds ago. He drops from his perch and demands the artifact back. "Can't anybody just sue us?" she asks. "What ever happened to the litigious society?"

- He advances, wrecking the lab.

## PAGE SIX:

- "Get him out of here, Heather! This equipment can't be replaced!"

- She sets the time-dial as the warrior swings at her, barely missing her as she athletically flips out of the way. But he smashes the mask. Sh*t. They needed it.

- She grabs him, starts to set the dial. "Time to take you back home, lover boy."

- He breaks free, they battle inside the lab, Henry hiding behind machinery. We understand that bravery is not his strong suit.

- Heather pushes the buttons and she shoves the ninja (or whatever) through the opening time portal. As he goes, he smashes a component on the controls.

- At the last second, he grabs her and is pulling her through with him. Ancient Japan is seen through the portal.

## PAGE SEVEN:

- She pulls away from him but he won't let go, no matter how hard she struggles and kicks. Henry even comes out from hiding to try to help.

- The twins are halfway through the closing portal…

- …when the ninja is zapped by a futuristic-looking ray blast fired from the past-side of the portal…!

- As the portal closes and the ninja lets go, Heather see her savior…and is only slightly shocked to see…

- …her dad holding the just-fired blaster. "Stop looking," he says. "To find me is to find doom."

- The portal closes. Henry and Heather look astonished, staring (at the reader) at the spot where the portal had been.

And that, of course, is our…

## CLIFFHANGER ENDING!

Mike's final costume design for the *Thief of Time*.
[©2006 Danny Fingeroth & Mike Manley]

*Mike and Danny, per their working method, discussed changes to and modifications of this plot via e-mail and telephone. The results of their conversations are Mike's art and Danny's dialogue and captions for the story, which you'll see, of course, elsewhere in the crossover.*

THE
END

# THE WRITE Now! DRAW! CROSSOVER

# Thief of Time: Pencil Roughs

**H**ere are Mike's early-stage pencil layouts for "A Glitch in Time." Each story page is accompanied by comments about it from Mike and Danny.

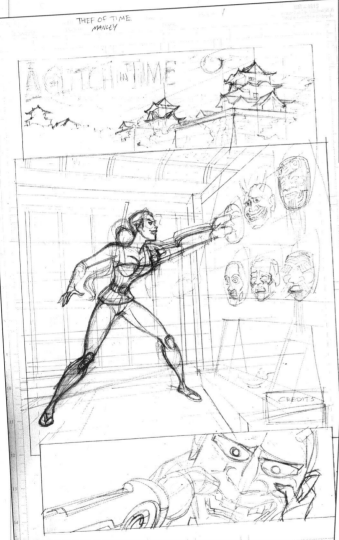

**DANNY:** *A lot of story to get in here. The last panel especially ended up looking different. I think we get the feel of the spirit of Heather Branscome, the Thief of Time, here.*

**MIKE:** This page gave me fits and in a way I'm still not happy with it. I think I was still really feeling my way here and trying to get into the story. Sometimes it takes a while to get to know the characters. I feel it took five issues of *Darkhawk* to get to know the character back in the day.

**DANNY:** Strong opening. This page one art is different from the plot description and, after Mike and I discussed the first version of the layouts for the page (seen on page 15), it morphed into this layout. Since Mike is also inking the story, all he needed to draw, in this stage, was something I could make out clearly enough to write dialogue from.

**MIKE:** *Ah, back in the saddle. A basic opening shot, establishing place and time, and a nice shot establishing our heroine and what she's after.*

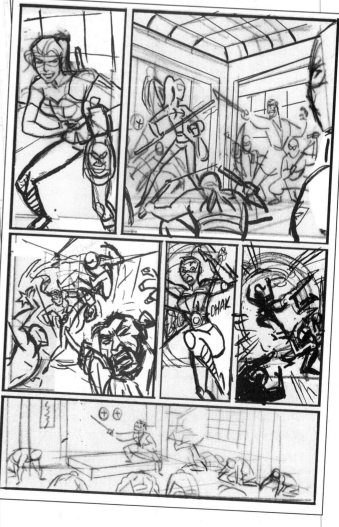

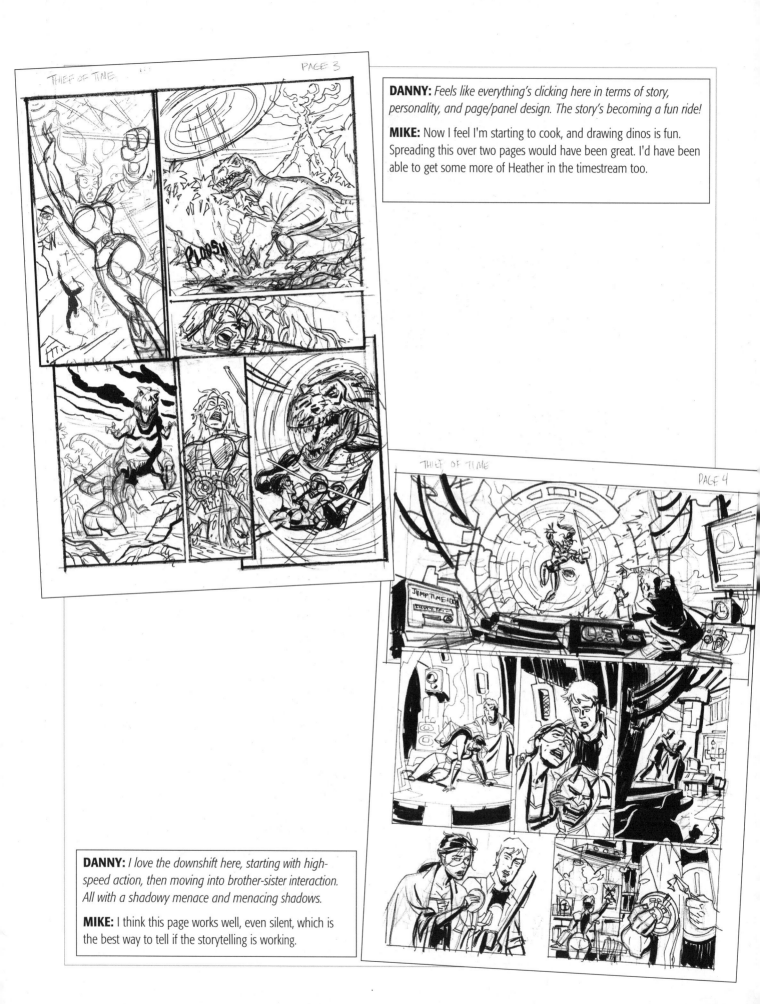

**DANNY:** *Feels like everything's clicking here in terms of story, personality, and page/panel design. The story's becoming a fun ride!*

**MIKE:** Now I feel I'm starting to cook, and drawing dinos is fun. Spreading this over two pages would have been great. I'd have been able to get some more of Heather in the timestream too.

**DANNY:** *I love the downshift here, starting with high-speed action, then moving into brother-sister interaction. All with a shadowy menace and menacing shadows.*

**MIKE:** I think this page works well, even silent, which is the best way to tell if the storytelling is working.

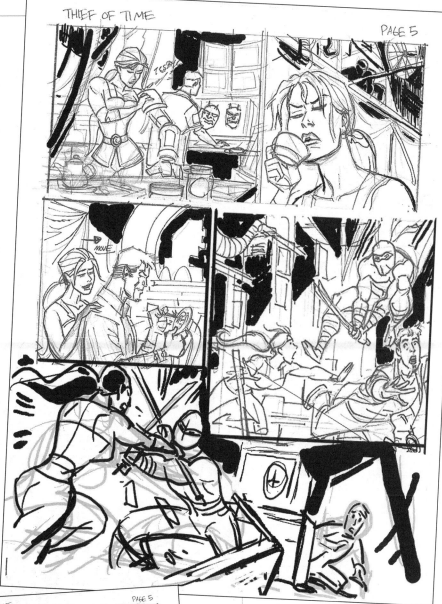

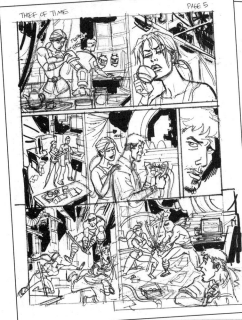

**DANNY:** *The earlier version of page 5 (see page 17) gave more room for the interplay between the siblings. But I felt we also needed to give room to the surprise of the Ninja hitchhiker attacking. I thought I could establish dialogue-wise what we needed to and still have the cool action happen. Mike pulled it off beautifully.*

**MIKE:** The main thing I was going for here is to show the warmth between brother and sister. This page is getting a bit cramped but I want to give Danny and myself room to explore this. In film or animation I'd have more room to play this out, more "real estate" to play up Heather's feelings for her lost father. But due to the constraints of having to shoehorn a lot into seven pages, I'm forced to condense this scene. I really wanted to play up what I think is vital here, that their father is missing and that they did something while time traveling that ended up being a big mistake, a burden they both have to live with.

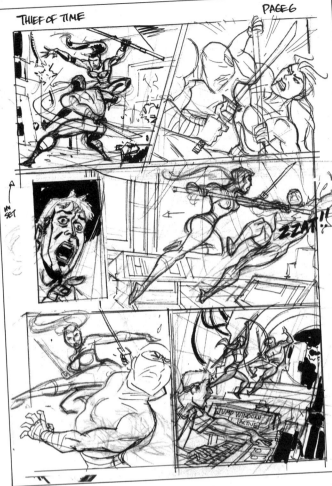

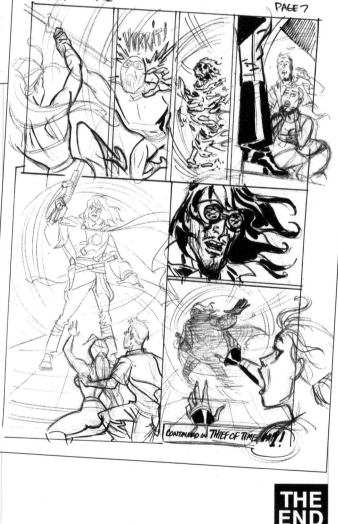

**DANNY:** *The big fight scene with the Ninja gives Mike space to show his—and Heather's—stuff. The big challenge for him as artist and me as scripter is to try to convey the sense of danger that our heroes are in, but not lose the sense of fun.*

**MIKE:** Now we get to some more action, as the Ninja from the past attacks them. He's certainly out of sorts and out of his time here. Eye flow and dynamics leading you from panel to panel are my chief concern here—strong dynamic gestures that show how skilled Heather is at combat.

**DANNY:** *The "complete unit of entertainment" wraps up here— and sets up a cliffhanger, as well. The father Heather and Henry have been trying to rescue ends up rescuing them, and tells them to quit chasing him if they know what's good for them. Hopefully, a reader feels like he or she has read a satisfying story (the Ninja hitchhiker was defeated), but also want to know what happens to the siblings—and their dad—next. And if their mucking with time travel will doom the universe. But, really, if a reader doesn't care about the characters, then all the impending end-of-the-world stuff doesn't carry much weight.*

**MIKE:** The big tease. The Ninja is zapped from off-screen by the father who comes to save the day. My idea is to have him sport different items from different times, as he's jumped all over in the timestream. I was thinking sort of Alan Quatermain crossed with Michael Rennie. Again having more space to play this scene out would have been nice, and if we do expand this to a 22-pager, I would probably want to revisit these scenes and add a little.

THE END

# Thief of Time: Script and Balloon Placement

**B**ecause "Glitch in Time" is a plot-first job, Danny had to write the dialogue, captions and sound effects after the pencils were done. With this method, it's also the writer's responsibility to indicate for the letterer (in this case, Mike) where the copy will go.

Balloon placement is an art in itself, since the word units become design elements that can affect how a reader responds to a page. The placement directs a reader's eyes to experience the story elements of a page in a certain order and rhythm.

Balloon placement is indicated on a photocopy, usually reduced to print size, of the art. Each unit of the script is numbered, and that number indicates where the script unit with the matching number is to be lettered.

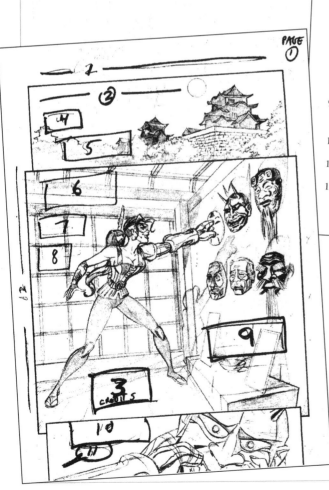

Thief of Time 7-pager/script/Fingeroth/6-12-04/page 1

**THIEF OF TIME
PREMIERE STORY
"A GLITCH IN TIME"
SCRIPT FOR 7 PAGES
DANNY FINGEROTH
6-12-04**

| 1 LOGO: | **THIEF OF TIME**<br>Created by **Danny Fingeroth** and **Mike Manley** |
|---|---|
| 2 TITLE: | **A *GLITCH* IN TIME** |
| 3 CREDITS: | DANNY FINGEROTH     MIKE MANLEY<br>writer     artist/letterer/colorist |

4 HEATHER-CAP (from here on HC):
    **History's** a funny thing.

5 HC:    We read about it in books and figure it's cold, hard **fact.** But that's not always true.

6 HC:    Case in point: nobody knows for sure where **Ninja** come from.

7 HC:    (small letters) Except maybe from mommy and daddy Ninja.

8 HC:    Some say they got their start here in **Ueno.** Could be.

9 HC:    If I had the time, maybe I'd ask around. After all, how often does a gal get to the **11th century?**

10 HC:    But I'm not sightseeing. I've come to Ueno-jo castle to **steal.**

11 HEATHER:    Come to momma, cutie.

12 Line along side:    *Thief of Time* and all related characters copyright c 2004 Danny Fingeroth and Mike Manley

Here's the script and balloon placement for page 1 of "Glitch"...

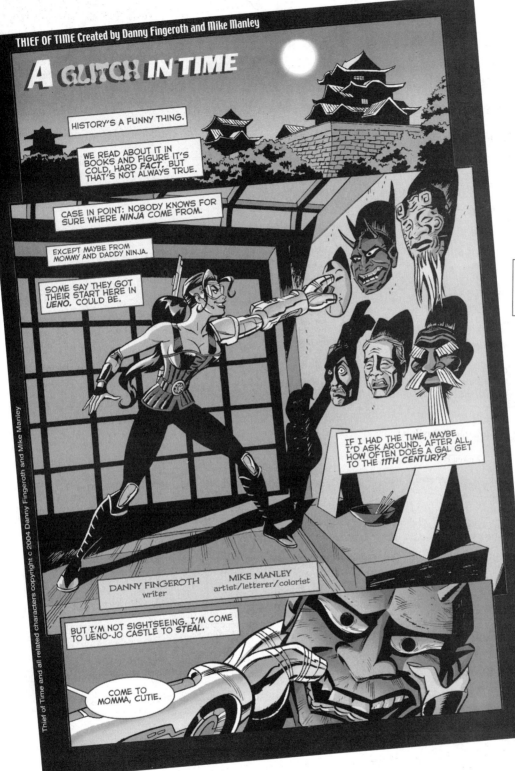

...and here's the lettered, finished page.

You can see the rest of the script and balloon placement for "Glitch" on the next four pages, as well as the lettering for pages 2 and 3.

Thief of Time 7-pager/script/Fingeroth/6-12-04/page 2

1 HC:                         Now it's time to get back to the fut--

2 NINJA (from off-panel):
                              <Halt!>*

3 FOOTNOTE (small letters):           *Translated from the Japanese.

4 HC:                         Okay. So there **are** Ninja in 1077 Ueno.

5 NINJA:                      <Return the **Noh mask,** intruder!>

6 NINJA:                      <Then prepare to **die.** >

7 HEATHER:                    My ancient Japanese is a tad rusty--

8 HEATHER:                    --but it doesn't sound to me like there's much **incentive** to return
                              this baby.

9 HEATHER:                    So, I'll let my **power-staff** do the talking—

10 SFX:                       SHZZKK

11 HEATHER:                   --and set the controls for **2004!**

12 HEATHER:                   **NO!**

13 SFX:                       VAKT

14 NINJA:                     <I will stop her!>

15 NINJA 2:                   <No! Fall back!>

16 NINJA:                     <The master will have our **heads!** >

17 NINJA:                     <The **Mask of the Seven Devils** is his favorite!>

18 NINJA:                     <But where has she taken Hiro? >

The fun of working "Marvel style" (plot first) is akin to musicians improvising together. Writer and artist "riff" on each other's contributions to create something new. Danny was able to take inspiration from the artwork to come up with dialogue that he may not have thought of if he'd written a full-script (that is, if he'd written the text at the same time as the panel descriptions).

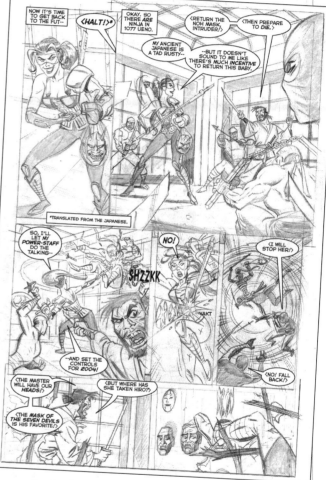

In plot first, the challenge for the scripter is to not repeat in words what the artist has shown, but to tell the details of the story and establish personality for the characters, all while keeping things going at a brisk, entertaining pace.

Mike has used computer lettering and coloring tools to perform those tasks. He'll tell you the details about how he did it in *Draw!* #9.

Thief of Time 7-pager/script/Fingeroth/6-12-04/page 3

1 HC:        Throwing-star damaged the **time-belt.**

2 HC:        Feedback loop's going **wild.**

3 HEATHER:  **AIEEEEE!!**

4 HC:        The **good** news: I landed somewhere.

5 HC:        The **bad** news: I landed somewhere.

6 SFX:       PLOOSH

7 HC:        At least my **skin** will come out of this looking good…

8 HC:        …if I don't **lose** my skin altogether!

9 HEATHER: You don't know you're a **vegetarian,** do ya, big guy?

10 HC:       Okay--if I override the **y-axis--**

11 HC:       --I have a shot at getting **out** of here.

12 HC:       **Bingo!**

13 HC:       But will I end up **when** I need to?

Bolded words in the comic are indicated, of course, by bolded words in the script.

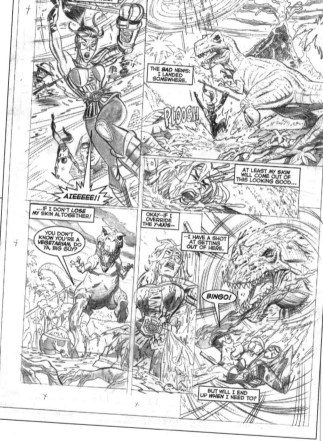

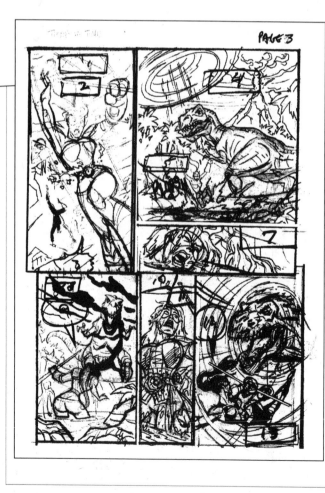

The job of art and script, in both plot-first and full-script jobs, is to make sure that when the reader gets to the bottom of a page, the question "What happens next?" is so compelling that he or she has no choice but to turn the page and keep reading.

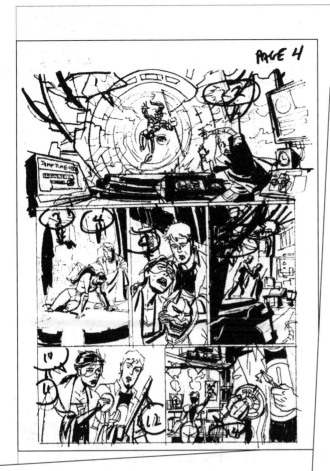

When placing balloons, especially if done on sketches, a writer has to be extra careful not to cover up important pieces of artwork. The shadowed, lurking figure in panel four of page four would have been easy to do that with.

Thief of Time 7-pager/script/Fingeroth/6-12-04/page 4

| | |
|---|---|
| 1 HEATHER (BST): | **HENRY!** |
| 2 HENRY: | **Heather!** |
| 3 HEATHER: | …freezing… |
| 4 HENRY: | This'll warm you up. |
| 5 HENRY: | Hey--you **got** it! |
| 6 HEATHER: | I **said** I would, didn't I? |
| 7 HENRY: | But you were jumping all over the **timescape…** |
| 8 HEATHER: | Ninja. |
| 9 HENRY: | **That'll** ruin your day. |
| 10 HEATHER: | I got the mask. That's all that matters. |
| 11 HEATHER: | You'd better check this out. |
| 12 HENRY: | Well, **here's** your problem… |
| 13 HENRY: | You're not supposed to stick razor sharp items into the time-belt, y'know. |
| 14 HEATHER: | We're getting **closer,** Henry. |

Thief of Time 7-pager/script/Fingeroth/6-12-04/page 5

| | |
|---|---|
| 1 HENRY: | The time-signature is definitely **his.** |
| 2 HEATHER: | So many false trails… |
| 3 HENRY: | And a few real ones. I **still** say this is nuts… |
| 4 HENRY: | …but if you're determined to **find** the old man… |
| 5 HENRY: | …then I'll be here to make sure you don't end **up** like him. |
| 6 HEATHER: | If I knew as much as **you,** bro… |
| 7 HEATHER: | …I'd probably want to give this up, too. Fortunately, I was an **English major.** |
| 8 HENRY: | You understand **everything** we're doing, Heather. |
| 9 HENRY: | And you know as well as I do how bad we **messed up** that time-- |
| 10 NINJA (BST): | <Give me the mask!> |
| 11 HEATHER: | **Hitchhiker!** |
| 12 HENRY: | Not **again!** |
| 13 HEATHER: | **Chill,** Henry! Under **control!** |
| 14 HENRY: | Get him **out** of here! |
| 15 SFX: | KLANNGG |

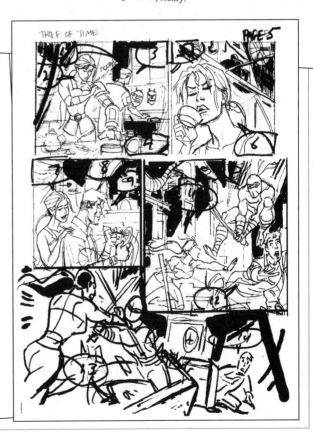

Thief of Time 7-pager/script/Fingeroth/6-12-04/page 6

1 SFX:          FWOK

2 SFX:          SWOOSH

3 HEATHER:      This is not the way to get a **second date**, sweetie!

4 NINJA:        **<DIE!>**

5 SFX:          KLANNGG

6 HEATHER:      Henry--?

7 HENRY:        Need a few seconds before I can **re-temporize--!**

8 HEATHER:      Maybe **that's** why you don't have a girlfriend!

9 SFX:          ZZAT!

10 NINJA:       **Aagh!**

11 HEATHER:     Does this count as **interfering** with **history?**

12 SFX:         BWAK

13 HENRY:       1077. Ueno. We have **warp-matrix.**

14 HEATHER;     Home, Jeeves!

15 HENRY:       Don't let **up!**

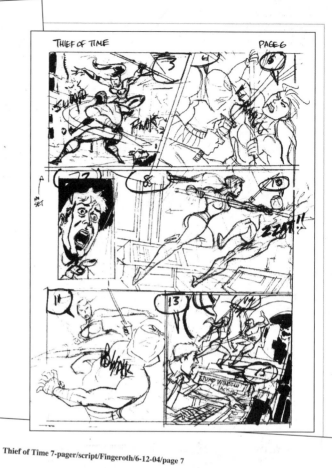

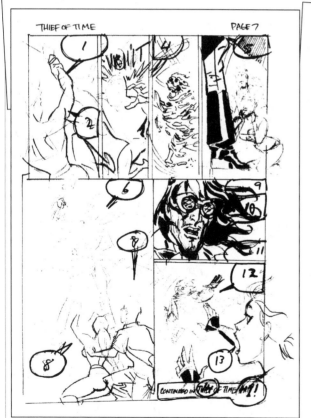

Thief of Time 7-pager/script/Fingeroth/6-12-04/page 7

1 HEATHER:      **No!** He's **pulling** me back **with** him!

2 HEATHER:      **Time-current's** too strong—

3 SFX:          VRIIIT

4 HEATHER:      **That** never happened before…!

5 DAD:          Oh, I've seen it **lots** of times…

6 DAD:          …**in** lots of times.

7 HENRY:        **Dad--?!**

8 HEATHER:      We **found** you!

9 DAD:          You found **nothing.**

10 DAD:         Your **blunders** through time threaten to unbalance **delicate forces.**

11 DAD:         Continue to pursue me…

12 DAD:         …and I'll have no choice but to **destroy** you **both.**

13 HEATHER:     **Wait!** Come **back--!**

14 BLURB:       **CONTINUED IN THIEF OF TIME #1**

> The big wrap-up. Everything in the story leads to this page. Especially on the last page of a story, all elements—plot, art, script, balloon placement—have to come together. The enjoyment of a good story can be diluted by a misfiring last page—and sometimes a story that's not so great can be salvaged by a strong finish.

# THE WRITE NOW! DRAW! CROSSOVER

# Thief of Time: The Full-Script

THIEF OF TIME
"A GLITCH IN TIME"
FULL-SCRIPT FOR 7 PAGE STORY
DANNY FINGEROTH

**W**hile Mike and Danny did "A Glitch in Time" plot-first style, the fact is that most comics today that aren't created by an individual writer-artist are done full-script style. In other words, the writer describes the action in each and every panel and, at the same time, writes the captions, dialogue and sound effects.

THIEF OF TIME
"A GLITCH IN TIME"
FULL-SCRIPT FOR 7 PAGE STORY
DANNY FINGEROTH

### PAGE ONE

**PANEL ONE:**
ART: 1/4 page establishing shot of Ueno-jo castle in Ueno, Japan. 1069. (See reference.) It's night. There's a full moon.

1 LOGO:    **THIEF OF TIME**
Created by **Danny Fingeroth** and **Mike Manley**

2 TITLE:    **A GLITCH IN TIME**

3 HEATHER-CAP (from here on HC):
**History's** a funny thing.

4 HC:    We read about it in books and figure it's cold, hard **fact.** But that's not always true.

**PANEL TWO:**
ART: 1/2 page shot—this is the "splash." **Heather Branscome,** dressed in her adventure duds, reaches for a beautiful Japanese mask on a wall, one among other distinctive masks. It's unclear if she's in the past or in present. Heather smiles expectantly. She's been after this thing for, oh, it seems like centuries.

5 HC:    Case in point: no one knows for sure where **Ninja** come from.

6 HC:    Except maybe from mommy and daddy ninja.

7 HC:    Some say they got their start here in **Ueno.** Could be.

8 HC:    If I had the time, maybe I'd ask around. After all, how often does a gal get to the 11th **Century?**

9 CREDITS:    **DANNY FINGEROTH**    **MIKE MANLEY**
writer    artist/letterer/colorist

**PANEL THREE:**
ART: 1/4 page shot. Close-up of the mask as Heather has it in her hands, having removed it from its perch on the wall.

10 HC:    But I'm not sightseeing. I've come to Ueno-Jo castle to **steal.**

11 HEATHER:    Come to momma, cutie.

### PAGE TWO

**PANEL ONE:**
ART: The mask in hand, heather is about to leave, when she is ordered to halt by off-panel foes.

1 HC:    Now it's time to get back to the fut—

2 NINJA (from off-panel):
<Halt!>*

3 FOOTNOTE (small letters):
*Translated from the Japanese.

**PANEL TWO:**
ART: Heather whirls to find herself surrounded by a dozen ancient Japanese soldiers. (Mike: Samurai? Ninjas? My Japanese history sucks.) She laughs at them –she's not here to fight, she's here to steal!

4 HC:    Okay. So there **are** Ninja in 1077 **Ueno.**

5 NINJA:    <Return the Noh mask, intruder!>.

6 NINJA:    <Then prepare to die. >

7 HEATHER: My ancient Japanese is a tad rusty--

In theory, with full-script, the writer doesn't have to see the script again until the story is published. (In practice, the writer often does see the story after it's been drawn and lettered, and may tweak the words to various degrees to make the story as good as possible.)

8 HEATHER:    --but it doesn't sound to me like there's much incentive to return this baby.

**PANEL THREE:**
ART: She reaches for a dial on her suit to make a quick getaway, as the guards attack, and she dodges arrows and throwing stars.

9 HEATHER:    So, I'll let my **power-staff** do the talking—

10 HEATHER:    --and set the controls for **2004!**

**PANEL FOUR:**
ART: A star hits the control and the time-dial is knocked off its setting.

11 HEATHER:    **NO!**

**PANEL FIVE:**
ART: She is gone in a flash into the time whirlpool you established on the cover. She has no idea *when* she's going, but it's got to be better than this!

12 NINJA:    <I will stop her!>

13 NINJA #2:    <No! Fall back!>

**PANEL SIX:**
ART: The amazed guards don't know what to make of her disappearance.

14 NINJA:    <The master will have our heads! >

15 NINJA:    <The **Mask of the Seven Devils** is his favorite!>

16 NINJA:    <But where has she taken Hiro? >

Since this book is intended to be as helpful as possible a guide to creating comics, Danny looked at the finished story and wrote a version of it in full-script style. He took what Mike had drawn and described it panel by panel, and also included the text parts of the story as they ended up on the printed page. Compare it to the finished story (shown elsewhere in this book), and you'll see how the full-script system works.

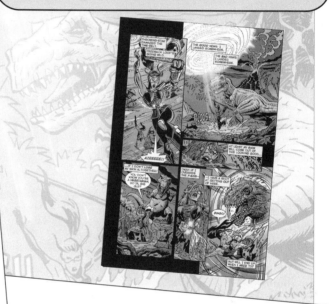

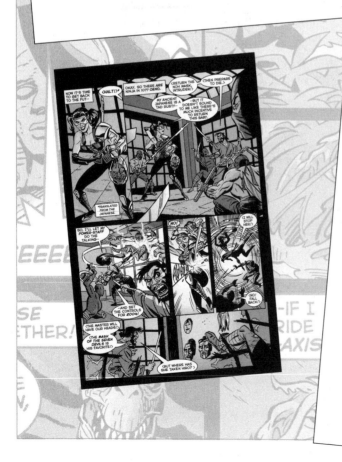

## PAGE THREE

**PANEL ONE:**
ART: Heather falls through a surreal time-transition dimension with iconic figures across time (a WWI soldier, the Sphinx, whatever you like. Make sure we see that one of the guards is traveling along with her, but don't call attention to that. The shot should focus on her.

1 HC:    Throwing-star damaged the time-belt.

2 HC:    Feedback loop's going wild.

3 HEATHER: **AIEEEEE!!**

**PANEL TWO:**
ART: She falls out of the time-whirlpool and lands in a swamp in a prehistoric setting. Dinosaurs, volcanoes, etc.

4 HC:    The **good** news: I landed somewhere.

5 HC:    The **bad** news: I landed somewhere.

6 SFX:    **PLOOSH**

**PANEL THREE:**
ART: Heather gasps for air as she rises from the swamp.

7 HC:    At least my **skin** will come out of this looking good…

**PANEL FOUR:**
ART: She realizes where she is and that a giant dino is charging at her.

8 HC:    …if I don't **lose** my skin altogether!

9 HEATHER: You don't know you're a **vegetarian**, do ya, big guy?

Many writers prefer full-script style because they feel it gives them more control over the pacing of a story. This is true to a degree, but even in full-script, there are still many creative choices left to the artist, such as panel size, panel and page design, and so on. Some artists like having the pacing of a story dictated, as it is with full-script, but others feel restrained by it, as if they're not being allowed to contribute as much as they could to a given story.

**PANEL THREE:**
ART: With heather wrapped in the blanket, Henry now sees that she's got the mask.

5 HENRY:          Hey--you got it!

6 HEATHER: I said I would, didn't I?

**PANEL FOUR:**
ART: They walk toward a bank of machinery, intending to evaluate her expedition. From the shadows, the ninja who tagged along watches them.

7 HENRY:          But you were jumping all over the **timescape**...

8 HEATHER: Ninja.

9 HENRY:          That'll ruin your day.

**PANEL FIVE:**
ART: Heather hands Henry her time-travel control disc.

10 HEATHER:          I got the mask. That's all that matters.

11 HEATHER:          You'd better check this out.

12 HENRY:          Well, **here's** your problem...

**PANEL SIX:**
ART: As Heather checks the time-map monitor, Henry removes a shard of throwing star from the time-control-belt.

**13 HENRY:**          **You're not supposed to stick razor sharp items into the time-belt, y'know.**

14 HEATHER:          We're getting closer, Henry.

**PANEL FIVE:**
ART: Heather turns the control dial on her belt, while she stares down the dino.

10 HC:          Okay--if I override the **y-axis**--

11 HC          --I have a shot at getting **out** of here.

**PANEL SIX:**
ART: She's sucked into the time-warp, leaving the frustrated dino behind.

12 HC:          **Bingo!**

13 HC:          But will I end up **when** I need to?

### PAGE FOUR

**PANEL ONE:**
ART: Heather appears inside her 2004 headquarters lab. It's a violent re-entry that sends ripples through the air and knocks stuff over and about in the lab, like someone opened a huge window in the middle of a hurricane. She's stressed from too long in the timestream.

1 HEATHER (BST):  **HENRY!**

2 HENRY:          **Heather!**

**PANEL TWO:**
ART: As the atmosphere settles back to normal, **Henry,** her **fraternal twin** brother, comes to her with a blanket. *(He looks related to her, of course, but definitely is more intense, with a gaze that won't let you go if he locks eyes with you. He's, temperamentally, Q to her James Bond. Brilliant technician and scientist, but not best-suited to field-ops.)* They're standing by banks of machinery, much of it digital, many computer screens.

3 HEATHER: ...freezing...

4 HENRY:          This'll warm you up.

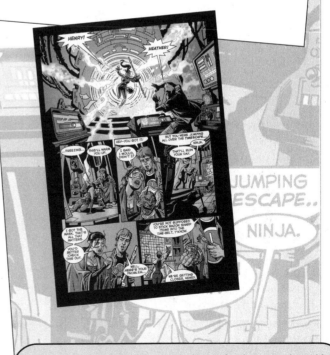

But love it or hate it, full-script is the predominant comics writing method today, at least at the major companies. Somewhere along the line, plot-first fell out of favor. So if you're going to try to play in that arena, then you have to learn how to write full-script.

## PAGE FIVE

**PANEL ONE:**
**ART:** As Heather removes the multi-purpose weapon-sleeve from her arm, Henry checks the mask against a computer file about it.

1 HENRY:  The time-signature is definitely **his.**

2 HEATHER:  So many false trails...

3 HENRY:  And a few real ones. I **still** say this is nuts...

4 HENRY:  ...but if you're determined to **find** the old man...

**PANEL TWO:**
ART: As Heather drinks a cup of tea and discusses strategy, we see the ninja in shadow above and behind her.

5 HENRY:  ...then I'll be here to make sure you don't end **up** like him.

6 HEATHER:  If I knew as much as **you,** bro...

**PANEL THREE:**
ART: Henry welds a spot on the belt as Heather tries to encourage him.

7 HEATHER:  ...I'd probably want to give this up, too. Fortunately, I was an **English major.**

8 HENRY:  You understand **everything** we're doing, Heather.

9 HENRY:  And you know as well as I do how bad we **messed up** that time--

**PANEL FOUR:**
ART: The ninja "hitchhiker" from the trip leaps down to attack them.

10 NINJA (BST):  <Give me the mask!>

11 HEATHER:  **Hitchhiker!**

12 HENRY:  Not **again!**

**PANEL FIVE:**
ART: While Heather battles the ninja (her staff against his sword), Henry cowers behind some machinery.

**13 HEATHER:**  Chill, **Henry! Under** control!

14 HENRY:  Get him **out** of here!

## PAGE SIX

PANEL ONE:
**ART:** Heather nimbly avoids a ninja sword swipe. She's good at this.

1 SFX:  FWOK

2 SFX:  SWOOSH

3 HEATHER:  This is not the way to get a **second date,** sweetie!

**PANEL TWO:**
ART: Ninja pursues the attack, up close and personal, pressing his sword against her staff, which she holds in front of herself. Looks like he may overwhelm her.

4 NINJA:  <DIE!>

5 HEATHER:  Henry--?

**PANEL THREE:**
ART: Henry, concerned—he needs more time.

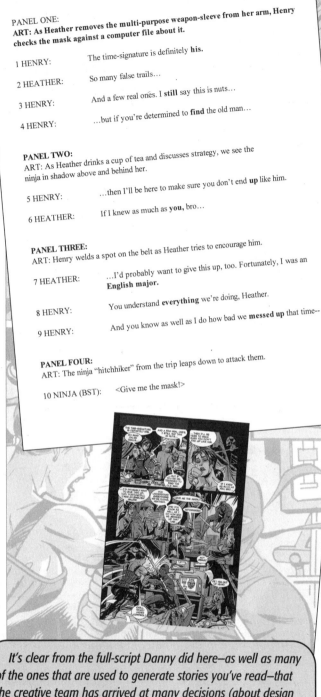

It's worth noting that full-script doesn't negate the other aspects of creating comics stories that we describe and demonstrate in this book. The discussions between writer and artist (and often an editor) and the various stages of character and story development still need to be done.

It's clear from the full-script Danny did here—as well as many of the ones that are used to generate stories you've read—that the creative team has arrived at many decisions (about design of people and places, overall tone, etc.) before the actual writing of the script, so that the script itself becomes a kind of shorthand communication between writer and artist, briefly describing each panel for people very familiar with the bigger picture of the world of the story.

The level of detail a writer will put in the art descriptions in a script (or a plot, for that matter) depends on the writer's personal style, as well as his or her relationship with the other members of the creative team.

6 HENRY:                 Need a few seconds before I can **re-temporize**--!

**PANEL FOUR:**
ART: Heather has a second wind. She leaps at the ninja, shocking him with the electrified end of her staff. He falls backward.

7 HEATHER:          Maybe **that's** why you don't have a girlfriend!

8 SFX:                 ZZAT!

9 NINJA:               **Aagh!**

**PANEL FIVE:**
ART: Heather delivers a roundhouse kick to the ninja.

10 HEATHER:        Does this count as **interfering** with **history?**

11 SFX:               BWAK!

**PANEL SIX:**
ART: She slams the ninja with one last swipe of her staff. Henry has the control panel set to send him back when he came from.

12 HENRY:          1077. Ueno. We have **warp-matrix.**

13 HEATHER;       Home, Jeeves!

14 HENRY:           Don't let **up!**

15 CONTROL PANEL READOUT:
                           JUMP WINDOW **ACTIVE**

If you're wondering what the "correct" format for writing a full-script is, the answer is—there isn't one. Unlike screenplays or teleplays, there is no single format for writing comics scripts. The essential thing is that your script clearly shows what's action, what's dialogue, and when a new page begins. Numbering each unit of copy with a corresponding number on a balloon placement photocopy of the art will help the letterer know where each copy unit goes.

And it's always a good idea to put your name and contact info and the story title and page number (manuscript page and/or story page) on every piece of script (and art) so that if they ever get separated, the other people on the creative and technical team will know what it's from. This will keep everybody from wasting time trying to figure out where a page of script or art belongs. Not to mention the fact that, if you're submitting work to an editor, wouldn't it be a shame if they loved it and wanted to hire you, but couldn't find your name or contact info?

**PAGE SEVEN**

PANEL ONE:
**ART: The ninja grabs her hand as he is sucked into a time-whirlpool. He is pulling her through with him.**

1 HEATHER:          **No!** He's **pulling** me back **with** him!

PANEL TWO:
ART: The ninja is hit from behind by some force-blast from inside the whirlpool.

2 HEATHER:          Huh? Something **zapped** him!

3 SFX:                VRIIIT

PANEL THREE:
ART: The ninja decomposes! Not a pretty sight.

4 HEATHER:          **Whoa!** Never saw **that** happen before!

PANEL FOUR:
ART: Heather and Henry look into the portal and are only shocked at who they see there. (We see a hint of him, maybe his boot.)

5 DAD:                Oh, I've seen it **lots** of times…

PANEL FIVE:
ART: Big shot of their FATHER, in time-traveling gear. He holds the just fired blaster in his hand. He's ticked off.

6 DAD:                …**in** lots of times.

7 HENRY:            Dad--?!

8 HEATHER:         We **found** you!

**PANEL SIX:**
ART: Close-up of Dad as he lectures them.

9 DAD:             You found **nothing.**

10 DAD:          Your **blunders** through time threaten to unbalance **delicate forces.**

11 DAD:          Continue to pursue me…

**PANEL SEVEN:**
ART: As Dad fades backwards away through the portal, he gestures for them to keep away from him. Heather calls for him to come back, although she knows it's hopeless.

12 DAD:          …and I'll have no choice but to **destroy** you **both.**

13 HEATHER:     **Wait!** Come **back--!**

14 BLURB:       **CONTINUED IN THIEF OF TIME #1!**

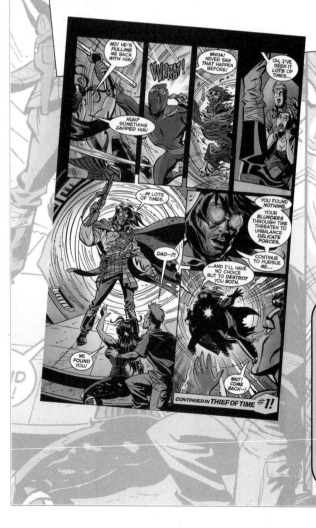

A related exercise that's very helpful—especially when you're starting out—is to write a full-script, and then do your own thumbnail sketches, and letter in the dialogue you've written. You don't have to be able to draw anything more than stick figures, and your lettering doesn't have to be legible to anyone but you. What you will, ideally, learn from doing this is how to describe action so it can be drawn by an artist (many beginners ask for impossibly simultaneous actions in one panel) and how many words a character can say before the balloons start overwhelming the artwork.

THE END

# Talking Thief of Time

## Danny and Mike discuss the creative process

W hat follows is more or less a transcript of a conversation we had on May 6th, 2004. What we tried to do was simulate a conversation about how we came up with our "Thief of Time" character. We discuss what issues we were dealing with as we tried to make something original yet not completely unfamiliar, mixing genres to come up with new takes on well-traveled archetypes. Combined with the notes and e-mails printed elsewhere in this issue and in *Draw!* #9, we hope to map the creative process as well as can be done without attaching electrodes to our brains. (Gotta save something for the sequel, don't we?)

We had many such conversations, mostly on the phone, some in person at conventions we both attended, but that we didn't record. We've tried to incorporate "highlights" of those conversations here. (The transcript has been edited by us for meaning and clarity.) You might find it interesting to compare what we discussed here and how the final story came out.

**— Danny Fingeroth & Mike Manley**

[**SPOILER WARNING:** Details of *Thief of Time* are, of course, discussed in the course of this conversation.]

**DANNY FINGEROTH:** A little background for the folks reading this. We each have a magazine that we do for TwoMorrows. I think it was me who said, "Mike, why don't we do a crossover?" And Mike said, "That's a good idea." Of course, we never really thought we'd have to sit down and do it. It seemed like a great idea when it was just theory. [laughs]

**MIKE MANLEY:** Right. And then we talked to John Morrow to see if he thought it was a good idea, to see if it was feasible, because we'd have to do a lot of coordination to make sure it can come out the same month, all that kind of stuff.

Conducted May 6, 2006
Transcribed by **Steven Tice**
Copy-edited by **Danny Fingeroth and Mike Manley**

**DF:** In time for the Comic-Con in San Diego. Now, I'm going to backtrack a little, because I thought it might be of interest to folks if we dug back in our archives and found some *Darkhawk* stuff. Tom DeFalco had come up with the very basic premise for *Darkhawk*, a three-page document, which then you and I and, I guess, Howard Mackie and Nelson Yomtov had worked out. And Greg Wright. Were you working on it when Greg Wright was editing?

**MM:** No. Initially I became involved in *Darkhawk* when Howard, who was editing *Quasar*, which I was penciling, asked me if I wanted to work on the book. Initially, Keith Pollard, I think, had done some *Darkhawk* character designs, and they weren't really happy with the way that it looked.

**DF:** I think Paul Neary was involved for five minutes.

**MM:** Right. So Howard asked me, and I said okay. I think in the beginning I wasn't really sure who was going to be writing it, because I don't think initially you were mentioned. I think maybe Tom was thinking of writing it himself in the beginning?

**DF:** If Howard had it, then I was already the writer, because Greg had put me on it.

**MM:** Nel didn't get involved until issue six, seven, eight, something like that.

**DF:** Anyway, there are ways in which our process for creating **Thief of Time** is similar, and ways in which it is different, from what you

Two Fingeroth/Manley creations meet. Darkhawk, from promotional art for the series' 1990 debut, and the Thief of Time. Art by Mike Manley. [Darkhawk ©2006 Marvel Characters, Inc.; Thief of Time ©2006 Danny Fingeroth & Mike Manley]

Portrait of a writer. Danny Fingeroth, in the caricature of him which appeared in the Bullpen Bulletins "Pro File" in April 1990 Marvel comics, right around the time work on *Darkhawk* began. Art by Steve Buccellato.

*would do at a large comics company. What we don't have is an editor, which people reading these issues won't have, if they're coming up with a proposal for a series, either. Either you'll be writing and drawing it, or you'll be working with a buddy, and you'll sort of have to arm-wrestle the way Mike and I are doing as we create this character.* [Mike laughs] *An editor would come in as a referee. The artist will want one thing, the writer will want the other thing, and the editor will go, "Here's my Solomonic decision." What we're trying to do here is more like what it would be like for you, the reader, trying to come up with a character to pitch to one of the major companies.*

**MM:** I think that, today, things are a lot different. When I was working on *Darkhawk*, it was basically, you're the gunslinger. The town has a job for you—they want you to kill this deadline. "Are you interested or not?" And depending upon whether subject matter tickles your fancy or whatever, or the money's good enough, sometimes, you decide, "Okay, yeah, I'll do it." At that time, in 1990/1991 when *Darkhawk* started, there wasn't as much of the independent stuff as there is today. Now it's a lot more common, especially since Image, for people to say, "Well, I'm going to create my own idea and I'm going to go and do it." Because in the case of something like *Darkhawk*, I wasn't the first guy thought of, but I created the design and I helped shape the concept, because it wasn't my concept to begin with. It's not something that I

*would have ever come up with or thought of doing, myself, on my own. I wasn't putting the elements into it that I wanted other than visually, maybe, and those elements are dependent upon the needs of the character.*

**DF:** *I think you had certain ideas of the character that were different than mine. I was leaning, because of my tastes, towards more of a "neo-Spider-Man" kind of a thing, with maybe a little bit more of an edge than Spider-Man had. And I think the various Darkhawk editors were in agreement. But I think you had a different idea of maybe making him more of an intergalactic Punisher-type character or something.*

And a portrait of an artist at work. Mike Manley in a Bret Blevins sketch which appeared in 1996's *Action Planet* #3. [Art ©2006 Bret Blevins.]

**MM:** I was thinking of the fact that, since this character was created by intergalactic weapons manufacturers, the idea of making it basically *Shazam!* crossed with *Spider-Man* was, to me, just walking down the same old territory over again. That whole "at home with the mom and the brothers and they can't find out who he is," that to me had been played out so much that that element of the character never appealed to me.

**DF:** *I thought of it as a chance for me to do my own Spider-Man, and for a kid—we still had significant numbers of children reading comics—to have his own teen super-character to identify with. It was an opportunity for me to create for readers of the '90s, kids and adults, a character that was of the '90s. "Oh, look! It's the very first issue, the*

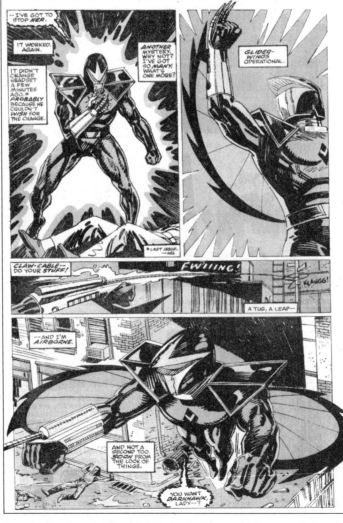

From *Darkhawk* #8, by Fingeroth & Manley. [©2006 Marvel Characters, Inc.]

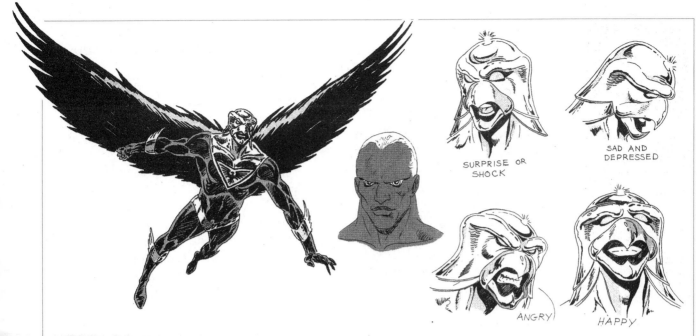

Keith Pollard's original character sketches for Darkhawk, done before Mike came onto the project. Keith brought a more literal interpretation to the "Hawk" part of the character's name. [Art ©2006 Bret Blevins.]

SURPRISE OR SHOCK

SAD AND DEPRESSED

ANGRY

HAPPY

very beginning!" And that sort of the philosophical difference of opinions between us is where an editor would come in, for better or worse. And they seemed, for whatever reasons, to generally come down on my side as far as the character's backstory and motivations. I have to believe, Mike, that since some of that art you did was so terrific on it that you were enjoying more of the run then you let on. And, of course, that was during the boom years, so whether you enjoyed it or not, you were definitely bringing home a nice royalty check each month.

**MM:** Yeah. But again, at three o'clock in the morning, royalties don't mean anything to me when I'm struggling to do a page or have fun on a project. The money in the abstract always sounds good, but when you're in the middle of a deadline, that doesn't motivate me to want to be a good artist or to do a good job on a story or to solve a problem.

**DF:** *Be that as it may, I just want to say that in this crossover, Mike and I are coming up with a character that we're creating from scratch. And we also want to end up with something that, when we're done, aside from*

being just an example of how it's done, we'll have a character to show editors and producers. A character we can maybe market. Mike and I are really looking forward to the day we can sue each other over ownership of this character. *[Mike laughs] We hope this character is that successful that we'll be forced to go to court to sue each other.*

**MM:** We'll be Abbott and Costello. *[Danny laughs]* We'll be Martin and Lewis.

**DF:** *We'll need Frank Sinatra to bring us back together.*

**MM:** That's right. I don't know who Frank Sinatra will be. *[laughter]* An important thing to note in this case is that when we started

Darkhawk's transformation from hero to civilian identity. A dramatic moment from *Darkhawk* #5. Art by Mike Manley and Ricardo Villagran. [©20004 Marvel Characters, Inc.]

From Mike and Danny's *Darkhawk* #7. [©2006 Marvel Characters, Inc.]

talking about this, what we're talking about is "What do you want to do? What's interesting to you? What would be fun to write? What would be fun to draw?" Which is completely different from something like **Darkhawk**, where the premise is already basically there–either you like it as it is, and maybe you can shape it a little bit, but it's pretty much handed to you. But here, from the ground floor, we're saying, "What do you want to do?" "Well, I like ninjas," or "I like samurai," or "I like pirates," or "I like robots," or "I like teenage girls with problems." That's a different starting place, too, than something like **Darkhawk**.

**DF:** *I will say, to Tom's credit in creating Darkhawk, it was pretty broad. He painted in broad strokes. We could have gone a lot of different ways. The Darkhawk character was a collaboration not just me between you, me and Tom, but also involved the three editors, Greg, Howard and Nel. And the assistants–John Lewandowski, Richard Ashford–threw in ideas, too, which is common with properties generated at big companies, and can sometimes lead to excellent outcomes. But I know what you're saying. But it might be informative to people to know that, in Tom's original premise, Darkhawk is about a kid, Chris Powell, whose father is a cop killed in the line of duty, and Chris finds this amulet that gives him powers. And my contribution to that part of the origin was to say: "You know what? There're a hundred stories where a kid's parent or uncle is killed and he vows to fight crime. What if he sees his father taking a payoff and he's completely disillusioned and he finds the power? Then he really has to figure out, "What the hell happened? Is my father a crook? Was everything he taught me a lie? Or do I have to bring my own father to justice?" So it was a mystery for the readers. It was a thing that made it less simple than, "My dad is a cop and sacrificed himself for a righteous cause. I must devote my life to fighting crime."*

**MM:** His dad didn't become the Uncle Ben of the series.

**DF:** *Right. And we played with that constantly, both when you were drawing it and when Tod Smith was drawing it. So those are the kinds of decisions that go into making a character. For our Thief of Time character–and I'm still looking for a better name–I said that I wanted to do something with a burglar, a high-tech burglar. And Mike said, "Let's make it a woman." Which was fine with me. And then I had this other idea about a time traveler, and Mike said, "Well, why don't we combine them and make it someone who is a burglar traveling through time?" Now, in a typical Marvel or DC sort of situation, the editor would then have been the coach, the tiebreaker, if Mike and I had had wildly divergent ideas. I guess the person who signs the voucher gets to make the final decision. [laughs]*

**MM:** And eventually, you and I could take this idea that we're doing now and still go and pitch it to DC. So this is a character generated from a desire on our own to do something

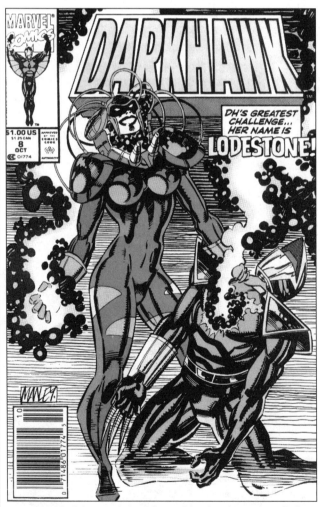

An early original character created for **Darkhawk** #8 by Danny and Mike: Lodestone. Her magnetic powers were just one of her attractions. [©2006 Marvel Characters, Inc.]

Some of the villains Danny & Mike created to make Darkhawk's life miserable. (Left:) Evilhawk from *Darkhawk* #24 (pencils by Mike Manley, inks by Tim Dzon & Aaron McClellan) and (right) Psi-Wolf from *Darkhawk* #17 (art by Mike Manley). [©2006 Marvel Characters, Inc.]

together, as opposed to somebody bringing you something and saying, "Hey, do you want to work on this?"

**DF:** *And we can then take it and self-publish it or try to sell it to a comics company or a movie or TV studio. Ironically, of course, if Mike and I should find a Hollywood studio or producer who's interested, we would probably have to make a deal to sign over the rights. Ideally, we'd be well-compensated and retain significant creative control, as well.*

**MM:** A lot of it depends on how in love you are with that particular property. I mean, if it's your "A" property, like something I'm very close to, say Monster Man, I'm not willing to let that go for anything less than a couple million dollars, let's say. But something like Thief of Time, I can sit down, have fun on it, I'm not as married to this. So if someone comes up and gets your typical

Mike Manley's cover for *Action Planet Comics* #1, featuring his creation Monster Man. [©2006 Mike Manley.]

six-figure Hollywood deal, because you go get Tom Cruise assigned to it so they can get good money, we'll probably get a deal somewhere in the mid-six figures, less your lawyer and your 30% going to the government, we could probably see a couple hundred thousand dollars each coming out of it.

**DF:** *That would be a best-case scenario. There's scenarios where we'd see, like $1,500.* [laughs]

**MM:** Well, that's true. I mean, I've had opportunities like that already, with other characters and concepts that I've created. I've had a six-figure deal that in the end I ended up turning down because I didn't necessarily trust the particular people I was talking to. And history showed me I was right, and those people went down in flames.

Another element of doing this that's

completely different than doing it for Marvel or DC, is that we'd likely have to give all our rights away to Marvel and DC for a pittance. In this case, we own 100%, 50% split between us. Then we decide at a later day if a given deal sounds appealing, if we're willing to trade these rights away.

And you also have to do things like a trademark search or a title search to see if anybody else had a character of the same name. This is part of the process of being a businessman as well as an artist.

**DF:** *Uh-oh! This sounds serious, Mike!* [laughter] *So now that we've talked about everything but the character, maybe we should talk about the character.*

*Based on some conversations we had, I put together a first version of the plot that I didn't love. I thought it was a good starting point, and Mike had his comments on that. That's the advantage to working with a thinking artist like Mike, who actually writes a lot of his own stuff. He'll*

Mike's own creations in action as Monster man battles the horror of the Hungus in *Action Planet* #3. [©2006 Mike Manley.]

challenge a writer, and help make a series or a story better.

*Now, the problem you're always going to face when doing genre adventure is, that you want to remind people of stuff they've seen before, because people who like this kind of material like a certain amount of familiarity, but you need it to be novel, as well.*

The creators' conversation continues on page 40.

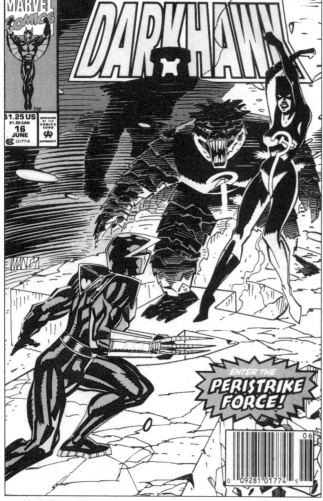

A trio of villains the Fingeroth-Manley team-supreme created for *Darkhawk* in issue #16. The Hawkster had to face off against Siberion, Volga Belle, and Scattershot—the Peristrike Force! [©2006 Marvel Characters, Inc.]

# THE WRITE NOW! DRAW! CROSSOVER

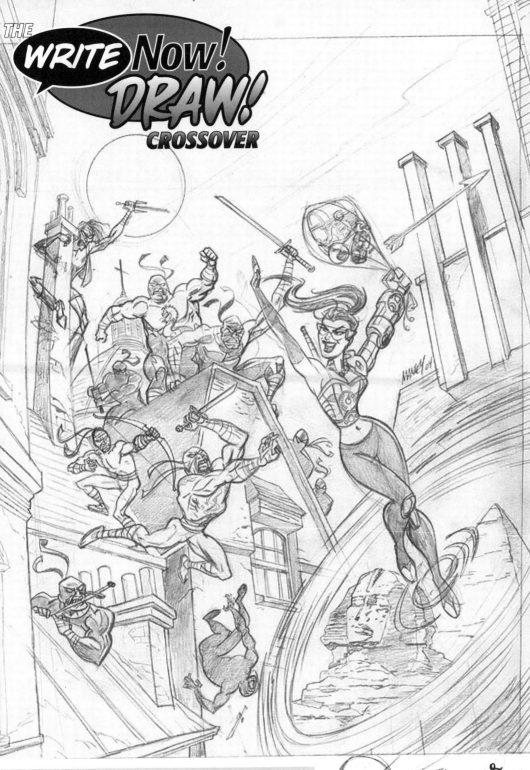

"My initial quick sketches or drawings of the character. The first image that popped into my mind was a female thief being chased across the rooftops of some European city, pursued by ninjas. These were done quickly directly with a brush and ink, and it ended up being the gem of the idea that became the cover image. I flopped the direction of the sketch to read better for the cover."

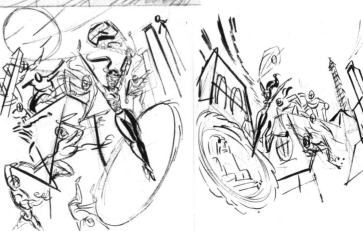

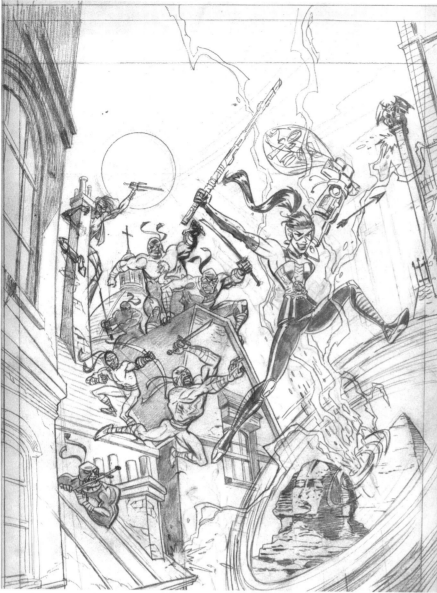

**ABOVE:** The final penciled version of the cover for *The Thief of Time*. On this page and the next page are some of Mike's rough sketches and designs for the thief's costume and appearance.

*The creators' conversation continues from page 38:*

**MIKE MANLEY:** In creating a drama, be it comics or a movie, etc., it's probable all the paths that you're going to walk dramatically have been walked by someone before. So, all you can do is try to put a little spin on the ball. There's been a zillion stories about pirates, or about private eyes, or guys flying through outer space, starship captains, and super-heroes. Nothing is really going to end up being completely unique. I mean, you hope your idea is fresh, but in genre fiction most ideas have probably been tried now.

So with *Thief*, my concern, visually, was try to do something that's interesting for the reader and that's fun for me to draw. A story, that even if it's time travel, not a unique idea certainly, has something that's a little different in some way. Some kind of hook. In one of the conversations we

had we discussed that we have to put a limit on Heather's time travel abilities. Otherwise there's no problem the person can't solve by simply saying, "Well, I'll go back five minutes before that event happened."

**DANNY FINGEROTH:** That's right. We had this discussion about how time travel stories can become incredibly complicated, and the question always comes back to, "If you can travel through time, why not just keep going back in time until you get it right?" That's actually the premise of *Groundhog Day*, I suppose, which is in a way a time travel story.

**MM:** We initially said, okay, it's going to be a thief, and we decided we'll make the thief a female character. Then we talked a little bit about the movie *Entrapment*, which was about a burglar, and looked at the elements that worked in that, and then we started talking about time travel. I actually went on the Internet and spent some time reading up on time travel.

Some scientists believe there is a possibility, depending upon faster-than-light drives or going the speed of light, that it is possible to do some form of time travel. There are others who believe there's time travel possibilities via wormholes, or black holes. There're a lot of different theories on it. So even though this is a fantasy, you still want to be able to have a layer in it that has some basis in science, so that at least you have some foundation on which to build a fantasy construct.

**DF:** There was one logistical problem we came up with what I think is an elegant solution for. I was having our heroine have to literally travel to different parts of the globe by jet or

something, to then go back in time so she would end up in that part of the world when she time-traveled. And you came up with the pseudo-science mumbo-jumbo (and I mean that in a good way) about some kind of global positioning thing, where she could end up coming out in the correct geographical spot, which simplified things nicely.

**MM:** Well, I figured since the Earth moves through time and space, and since she's going to jump through time, the time-vest she wears would have to have some ability, maybe in conjunction with some machine, computer program, a guy working the machine back at the home base, tracking her in relationship to the Earth, so that you can say, "When I'm going through time to April 14, 1876, at 3:00 AM," you would know exactly where the Earth would be in order to do that, or else you'd pop into space, because the Earth might be on the other side of the sun.

**DF:** This new version of the plot felt more organic to me. Does it work better for you?

**MM:** It does. And we were also trying to decide if the key time travel scene in her first story would take her to ancient Greece or medieval Japan.

**DF:** In this case, I think it's more what you're in the mood to draw. The story point would be similar in either case, so it's what's more fun for Mike to do artwise?

**MM:** So I settled on ancient Japan, because, for me, ancient Japan and samurai or are going to be more fun to draw.

I went through step-by-step, reading the plot and wrote down what

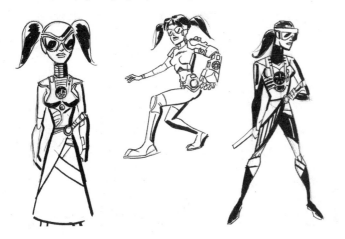

Heather's key motivation is. The fact that she's trying to find her father, who invented this time-vest that she wears, and he's lost in the time stream. She wants somehow, to locate her father in the time stream and basically save him. And then we had a big, long talk about how there had to be some reason why she couldn't just pop in two seconds before he turned the vest on and got himself lost in time, why didn't she just do that?

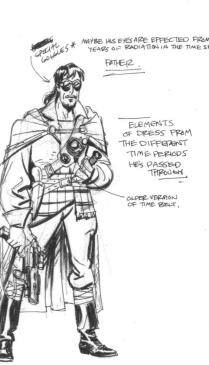

SPECIAL GOGGLES * MAYBE HIS EYES ARE EFFECTED FROM YEARS OF RADIATION IN THE TIME STREAM?

FATHER

ELEMENTS OF DRESS FROM THE DIFFERENT TIME PERIODS HE'S PASSED THROUGH

OLDER VERSION OF TIME BELT.

TIME PULSE GUN / GUN THAT AGES THINGS?

All of this is in my mind when I'm reading your plot that you just sent, which was really good. I was thinking, what if the dad's time vest was damaged and maybe there was something wrong with it initially, a design flaw maybe, so that he keeps skipping through time like a stone thrown across a lake, and every time that he pops into a different time, he sends out a slight "ripple." And that slight ripple maybe subtly affects time after that. So he's sending out slight ripples in time, that are generated by the suit "punching holes" through time. And, since it's a random thing and her brother Henry's helping her track her father down, I was just thinking, maybe Henry's job could be to track where his father goes when he's using the vest. To see if there's a pattern to the jumps in time that their father's making as he skips through time, trying to triangulate where Dad will be next, so that he can say, "Well, we think that, based on this algorithm that I'm running"—some chaos theory computer program—"we predict our father will appear in 1776 in Malta," or something like that.

**DF:** Yeah. From *The Time Machine* to *The Terminator* to *Back to the Future*, to just about any time travel story, I think you just have to establish the rules of time travel and figure the audience will be willing to go along for the ride as long as the story points are compelling enough to

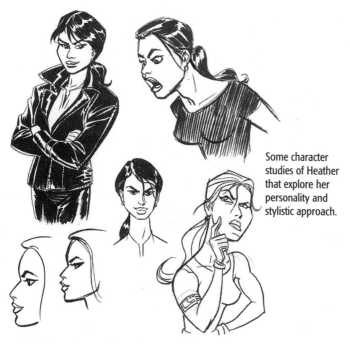

Some character studies of Heather that explore her personality and stylistic approach.

make them want to. Otherwise, you go into territory where you're trying so hard to explain how and why of something that's impossible in the first place, that you end up sabotaging your story. Let's face it, what do people remember about *Back to the Future*? The time-traveling DeLorean and the fact that Michael J. Fox had to make sure his parents got together so that he would be born, which, when you think about it, he must already have succeeded, or else how could we be watching a movie about his character in the first place? But you don't think about that as you watch the movie. You just take the filmmakers' and characters' words for it that what they're trying to achieve—the McGuffin, as Hitchcock called it—is important.

**MM:** Sure, the more logically you set it up, the more chance the reader or viewer will buy into it.

**DF:** Agreed.

**MM:** I did think, at the end, in our story, having the father show up was kind of a cool thing. Now, we could have some reason that that happened, we'll need to work that out, because we have a limited amount of space with the initial comic.

**DF:** That was definitely going to be the cliffhanger. Because, as you were just saying, he pops in and out of time. There could be a pattern to it, but one that maybe they haven't quite figured out. Now, does he want to be rescued? That's another issue.

**MM:** Basically, the main thing for me as an artist working on the story with you was to figure out logical parameters within this fantasy construct so if this person can travel through time, they can't just simply solve every problem they encounter by just going, "Oh, well, I'll just dial back before that happened, ding, problem solved!" So there should be some reason that every time they actually go into the time stream, there's a real possibility that if they do something wrong, they could really screw up the present. I think it would be a

good thing to have it set up at the beginning that there was a real consequence every time Heather jumped through time, and if she did something wrong, she could really screw something up.

**DF:** You know, this goes back to our original discussion, the way that you even said, "Why doesn't she go back a week and invest in whatever stock went up the following week? Why would she have to be a thief?" Which is why I put the message for the father in there. Because we're back to that same thing, why go to such elaborate means just to generate money if you can know how future financial markets are going to turn out?

**MM:** Well, here's the other plot idea I had in relating to the father. Maybe via his skipping through time, he's sort of set himself up financially or science-wise. Maybe he's trapped, maybe there's some reason why he can't take the vest off, maybe it's bonded to his skin, whatever. So he's always going to have to jump through time.

**DF:** Because if he takes off the vest, he loses any hope of ever getting back to his home time.

**MM:** Right. And maybe he hasn't been able to fix it because he doesn't have the 2004 technology to repair the vest. Or maybe he's working on it, it's going to take him a while in the past to gather the materials he needs to fix the vest or something. Like a stone skipping through time, so you never know where the next skip will send you.

**DF:** He has to triangulate where he's going to be. So now the question still comes up, why is she stealing stuff in the past, if it's not to find clues for him? If she's on an assignment from the Emperor of Japan, that's one thing, that specific favor, or maybe he has something she needs.

**MM:** That's a cool idea. Maybe she's trying to track him, so maybe by stealing this mask from the past and delivering it to the emperor of Japan in the future, he gives her some photograph or some information about where her father was in Japan at some point.

**BELOW:** My thumbnail breakdowns. This is where it all starts as I sketch out thumbnails based on Danny's plot. These will go through a refining process but I want to get the visual images in my head down as quickly as they occur.

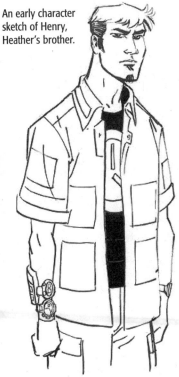

An early character sketch of Henry, Heather's brother.

**DF:** On another topic, we need to figure out what her "moral compass" is. There's a lot of things that heroes don't do, and we don't feel bad about them because they're not rubbed in our faces, but even if she's not a classical super-hero, even if she's not out to save the world, but just is out to find her dad—and I think it would be nice if she had some altruistic characteristics—but if she's going into a sinking ship, takes the money, and goes, "Oh, I'd love to save you guys, but I can't mess with history. Bye!" "Glub, glub." [laughs]

**MM:** Well, see, I think that that is a lot more interesting. If you know for a fact that you pop into time in Chicago, and there's a fire, and there's a baby, and that baby is trapped in the fire, do you save that baby, or do you not save that baby? Because if you save that baby, the kid might grow up to be Adolf Hitler? Maybe they did that once. Maybe she did save somebody, and later on it caused something really bad to happen because she altered the course of somebody else's life in the time stream?

**DF:** I guess the question then becomes, for us, do we make that something that happened to her, or does she learn it on-panel in one of our stories?

**MM:** Going over the notes that you had with your plot, I thought that there was the perfect place to do that, to say, "Remember what happened that time you went to Malta?"

**DF:** Maybe that's what set her dad off bouncing around the time stream was trying to do something that would change history in a certain way.

**MM:** Right. And you have the sequence on page four where she's talking to Henry, and they have that discussion on page four and page five. And I would think that would be a good time for him to say, "Remember what happened in Malta?" We don't have to say what that Malta thing is, you sort of leave it like the McGuffin in Hitchcock. You leave the gun there, and then you come back in the next story, where we have the space, and can elaborate on it. You know that's what Stan Lee would do, Stan would have the little thing there, "Remember the last time you tried to save somebody, Chicago disappeared!" [laughs]

**DF:** We haven't really spoken too much about her personality. She seems somewhat impulsive, she seems pretty creative, but that's one thing I want to build up more of.

**MM:** For me, the easiest thing is saying, "She's 20, she's hot, she's Asian, she's smart, she's got a wicked sense of humor, and she likes to collect crickets." It's easy to say that. It's a lot harder to work out the logistics, and more importantly, to work out the logistics of the story and the universe, and then it's easier to deal with the type of person she is. That's the easiest part of this.

**DF:** I think you can look at it the other way, too. If you know what kind of a person she is, that dictates the choices she makes, which is what the story is, how this person reacts under pressure. For me, that's what generates the most interesting stories, because they make sure you have a story that could only happen to the protagonist you're creating. But you need both—a compelling character who also does cool stuff that makes sense.

**MM:** Definitely. For instance, if saving somebody in the past causes some horrible thing to possibly happen in the future, and she's a moral person, then it would have to really affect her if she jumped into the past and there was a fire going and she could save somebody, and she's forced to not do it. That would really screw with you.

**DF:** That's a great crucible of her personality and of her values.

**MM:** Right. So her strength of character is defined by the fact that she has to have the strength of character to not do what her natural impulse would be—to, for instance, pull a burning baby from a fire. Let's say you were going to time travel, and you could go back to the Titanic and steal the jewels that were on the Titanic, because they're all going to be lost anyway, so if you took all the stuff that was in the safe, you're not affecting anybody because you can go sell that stuff, or melt it down and make gold bars, or whatever. But if you saved somebody from the Titanic, that may irrevocably alter the future.

**DF:** But if you didn't, what kind of horrible person would you be, to walk past people you knew were doomed, but not do anything to save them because you knew there would likely be consequences that were far worse? That could even be part of why her dad doesn't want to be rescued. Maybe dad thinks he's on the verge of figuring out a way to alter events without negative consequences, but Heather and Henry don't believe it's possible. So everybody concerned believes passionately that they're doing the right thing—which is what dramatic conflict is all about.

*This concludes our discussion about the collaborative process of Thief of Time. We hope it gave you a window into the world of our creative process. —Danny & Mike*

# MY PROCESS, THE SCRIPT TO PRINT
### BY MIKE MANLEY

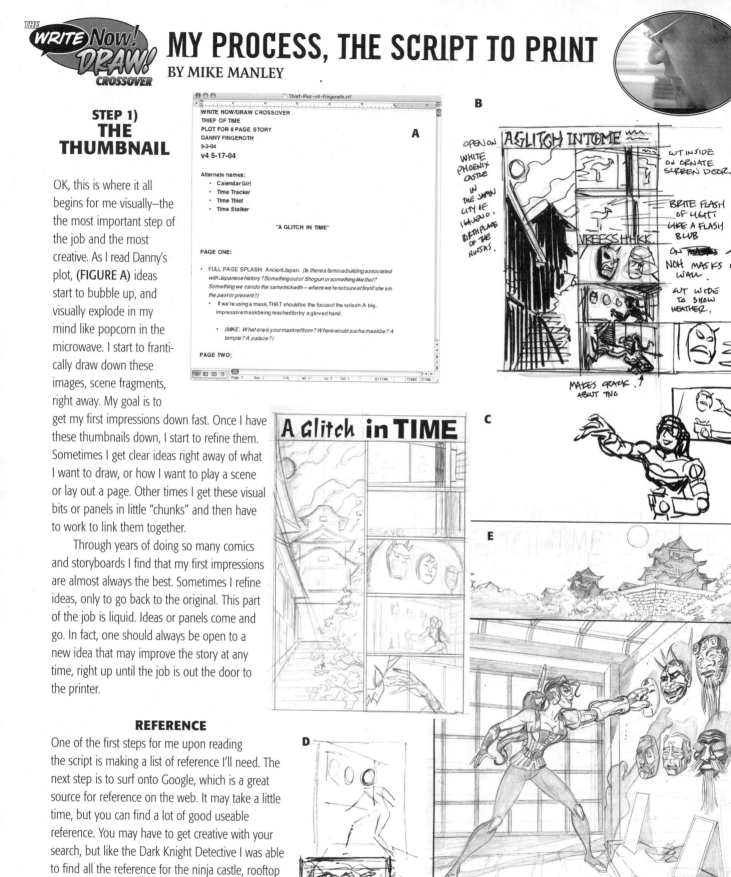

## STEP 1)
## THE THUMBNAIL

OK, this is where it all begins for me visually—the the most important step of the job and the most creative. As I read Danny's plot, (FIGURE A) ideas start to bubble up, and visually explode in my mind like popcorn in the microwave. I start to frantically draw down these images, scene fragments, right away. My goal is to get my first impressions down fast. Once I have these thumbnails down, I start to refine them. Sometimes I get clear ideas right away of what I want to draw, or how I want to play a scene or lay out a page. Other times I get these visual bits or panels in little "chunks" and then have to work to link them together.

Through years of doing so many comics and storyboards I find that my first impressions are almost always the best. Sometimes I refine ideas, only to go back to the original. This part of the job is liquid. Ideas or panels come and go. In fact, one should always be open to a new idea that may improve the story at any time, right up until the job is out the door to the printer.

### REFERENCE

One of the first steps for me upon reading the script is making a list of reference I'll need. The next step is to surf onto Google, which is a great source for reference on the web. It may take a little time, but you can find a lot of good useable reference. You may have to get creative with your search, but like the Dark Knight Detective I was able to find all the reference for the ninja castle, rooftop scenes, ninjas, etc., without leaving my studio.

And I'll go on record here as saying there is no such thing as too much reference. Better to have more than you need. Unfortunately due to copyright reasons I am not able to reprint the images I got from my search. But if you start searching for Noh masks,

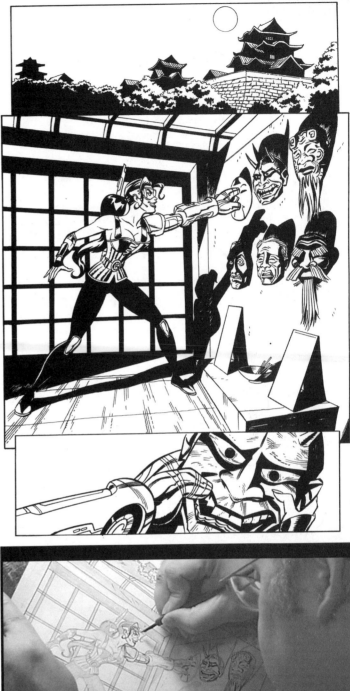

ninjas, and French rooftops on Google, I bet you'll come along the same reference I did.

FIGURE (B) These are the thumbnails that were my first draft at breaking down Danny's plot visually. Danny and I are working in what has come to be called the "Marvel Style" of plotting and scripting. In the "Marvel Style" the writer provides a plot, but little or no dialogue, often leaving the number of panels per page or even how long a scene plays out up to the artist. The writer then scripts the pages either from the artist's breakdowns or full pencils. In this style the artist controls the pacing more, unlike a full-script, where the writer is the first to control the pacing of the story by breaking each page down into specific panels as well as providing all the dialogue and captions.

Since we have worked Marvel Style before while producing *Darkhawk* for Marvel, Danny and I both felt comfortable working as we did in the past. I prefer plots in comics as it gives me a lot more freedom, especially on super-hero or action comics.

FIGURE (C) My second pass on the rough layout. I was initially thinking more cinematically, slowly moving into the ninja castle and into an inner chamber the Thief time-jumps into. The idea was to slowly build up to a reveal of her. Since I have been doing storyboards a lot in the last eight-plus years on shows like *Batman*, *Superman,* and *Samurai Jack,* and recently *Fairly Odd Parents*, this has really reinforced and honed my cinematic storytelling skills and the motto, "tell the story."

The problem I ran into quickly in this case was space, or the lack thereof. Since this is only an eight-page comic with one page comprising the cover, I really had only seven pages to tell this story, introduce the heroine, the thrilling conflict and the cliffhanger. Not a lot of space, especially when I need to get some nice action scenes in there as well as room for Danny to write exposition explaining some of the back story. After e-mailing back and forth with Danny, I decided to just cut to the chase and show an establishing shot to show where the action was happening and cut right to Heather already in the castle chamber and reaching for the mask.

FIGURE (D) This is the new rough for the splash page which was quickly drawn on a Post-it Note.

FIGURE (E) The final tight penciled page. This, along with the final layout, is the most important part of the job. This is the visual foundation on which everything else will hang, and for me the most creative part of the job.

Sure, penciling a nice figure or page and inking are always very creative as procedures themselves, but a poor beginning, bad layout and

**ABOVE (LEFT):** A picture of Mike penciling the splash page along with the thumbnail from the *DRAW!* DVD *How to Draw Comics from Script to Print*.
**TOP (RIGHT):** The final inked splash page.
**ABOVE:** A shot of Mike inking the splash page, also from the DVD.

confusing storytelling will not be overcome by the best rendering. Comics are meant to be read as a narrative, not as a series of cool drawings next to each other.

**A**

PAGE TWO:

• **Heather Branscome,** dressed in her adventure duds, reaches for a beautiful (JADE?) **Japanese mask** on a pedestal. From the décor, it's unclear if she's in the past or in present. HB is clearly a 2004 woman. She makes some wisecrack about the internet or Tivo to make that point. Heather smiles expectantly. She's been after this thing for, oh, it seems like centuries.

    • *Note to Mike re her wisecracks: One of the reasons Spider-Man wisecracks is to relieve the tension of death-defying moments. Same with her. I'm modeling her on Jennifer Garner in Alias. Not a comedian, but never without a wry quip, either.*

• As she's about to grasp the mask, she is ordered to stop —

• --and whirls to find herself surrounded by a dozen ancient Japanese soldiers. (Mike: Samurai? Ninjas? My Japanese history sucks.) She laughs at them --she's not here to fight, she's here to steal!--and reaches for a dial on her suit to make a quick getaway.

• But the guards attack, and she is dodging arrows and throwing stars, one of which hits the control and the time-dial is knocked off its setting.

• She grabs the mask and, clutching it to her bosom, she turns the switch on her costume anyway, and is gone in a flash (or into the time whirlpool you established on the cover). She has no idea *when* she's going, but it's got to be better than this!

PAGE THREE:

**B**

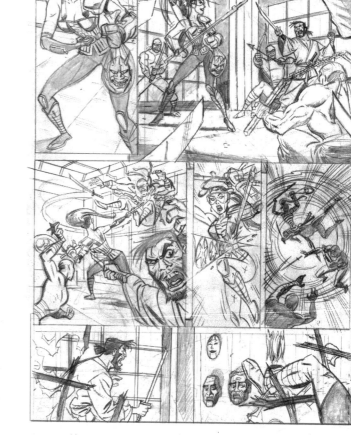

**C**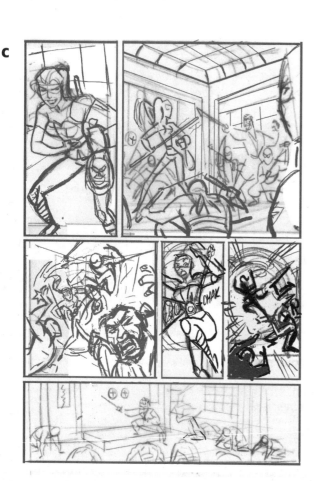

**D**

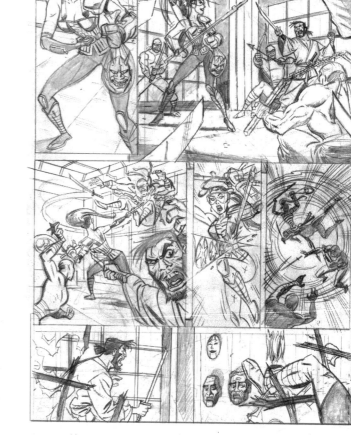

As you can see on the second page of the script, we get right into the action. It's very busy and there is a lot going on. In my initial rough pass **(FIGURE B)** I was working out how to break down the action of the ninjas damaging the time belt, and Heather's time-jump, leaving the ninjas to ponder what happened, and to clearly show that she had vanished with the mask. That was the scene I had to clearly end on. If this was a storyboard I would be doing more drawings like the ninja tossing the throwing star in sequence. I wanted to show she could kick ass too, but I didn't have much space to play out a fight scene. So clarity is crucial. I have to ask myself, do I sacrifice storytelling for dynamics? I don't want to, so I keep thinking and sketching.

I take a second pass at the page **(FIGURE C)** and e-mail that to Danny. He felt there were too many small figures on the page. He wanted more *Mighty Marvel*-type action. I felt I needed to show mostly medium shots for clarity, so I started to push foreground and background elements to get interesting and clear overlays **(Panels 2 and 3)**. I don't have to show every ninja, I can show parts, like swords, etc., to indicate there are

more ninjas surrounding her, I can use them also as design elements reinforcing the focal point of your eye to look at Heather. I replaced the last panel and composed it to focus on the head ninja and the missing mask by using the gesture of the ninja's leg in the foreground to lead your eye right to it.

## PENCILING

The next step as is to take my layout and blow it up on my copy machine roughly 130% onto 11" x 17" paper. I then take that copy to my light table and put it under the sheet of 2-ply Bristol I will draw the final page on. I then start to trace off the layout. Now I want to stress something here. When I say trace, I don't mean a dead-line tracing, I mean sketching or drawing. I can in some cases draw my finished page completely on the lightbox. I'm drawing and using the image coming through on the lightbox essentially as an underdrawing, as if I had lightly penciled the page in blue pencil. I don't want that dead line you get with a tracing.

I'm using the Bill Cole 500 series Strathmore with the plate finish to draw on. I like a smooth surface for penciling as it's easier to keep clean and erase and it takes the pen well. I flip off the lightbox and go back over the page and continue to finish and touch-up the pencils. Normally I don't draw this finished for myself to ink, I only pencil this tight if someone else is going to ink the page, but for the purpose of this tutorial I am going all out. I pencil with an HB pencil lead in a 5mm mechanical lead holder. I like a fairly soft lead as I don't like to press down hard when I draw. It also cleans up nicely if I don't dig down into the board. Every penciler has his or her own preference for lead and paper. Some like hard lead and rough paper and some vice-versa.

The spotting or arrangement of blacks will be important in making this page "read." I drew the panel where Heather jumps with higher contrast as that also helps rest the eye and give some contrast to the busier panels. Bold shapes and blacks against detail give the eye a variety and I feel give the comic page a lot of visual spice. The entire time I'm drawing the pages I'm always thinking of the fact that these penciled pages are not the final step. As nice as they may be in places, they are a

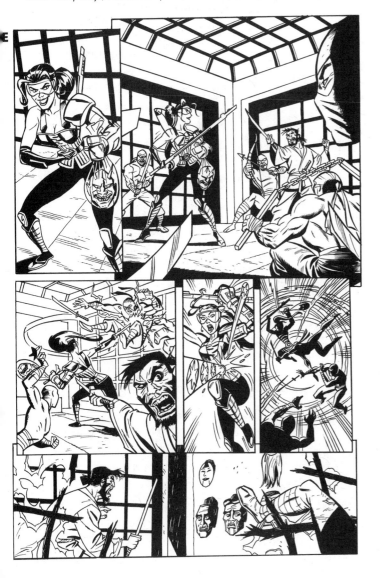

**BELOW:** Mike's light table showing the enlarged photocopy of page 7 which he places beneath the sheet of 2-ply bristol and uses as an underdrawing. The finished page is to the left.

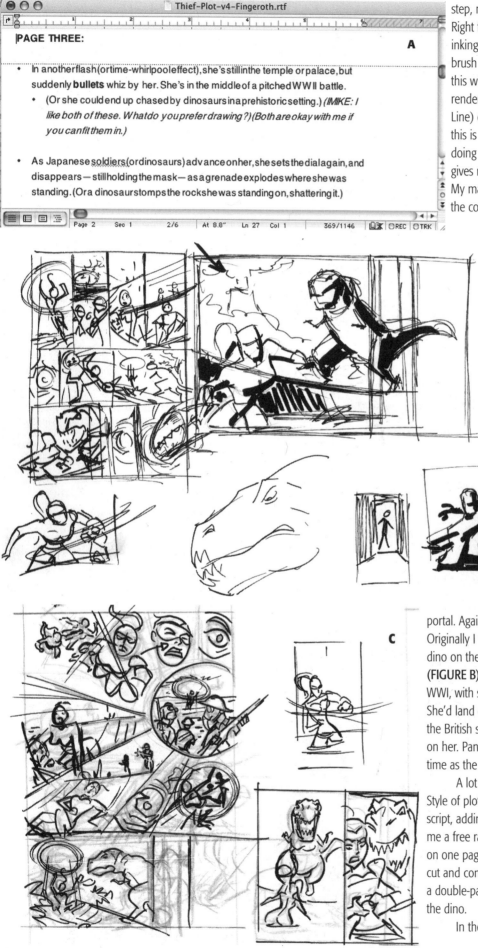

**PAGE THREE:** **A**

- In another flash (or time-whirlpool effect), she's still in the temple or palace, but suddenly **bullets** whiz by her. She's in the middle of a pitched WWII battle.
  - (Or she could end up chased by dinosaurs in a prehistoric setting.) *(IMIKE: I like both of these. What do you prefer drawing?) (Both are okay with me if you can fit them in.)*

- As Japanese soldiers (or dinosaurs) advance on her, she sets the dial again, and disappears — still holding the mask — as a grenade explodes where she was standing. (Or a dinosaur stomps the rock she was standing on, shattering it.)

step, not the final art. The final art is the inked pages. Right from the beginning I am thinking how I will will be inking the final page; if I will use a brush or pen, thick brush lines against thin pen lines, or textures. Do I want this with clean or rough inking, a lot of rendering or little rendering, relying more on "La Ligne Claire" (The Clear Line) exemplified by artists such as Hergé (*Tintin*)? All of this is in my mind as I pencil the pages, and since I am doing everything, including the coloring on this job, this gives me many more options than if I was only penciling. My main complaint about modern comics is that often the coloring and the art seem to be at odds instead of complementing each other.

For me, the big fight some days, even after all the pages I've done during my 20 years in comics, is keeping the freedom and energy I have in my roughs and sketches. I always like them better than the finished art. Maybe it's that a sketch is always becoming something, it's not as finite as a finished page. A sketch has no boundaries. My goal is to one day do pages that have the loose energy of my sketches without losing the drawing.

Now page three was a fun but very tough page to do. Danny gave me a lot of freedom here to stage the action and to allow me to draw some really cool stuff. I also had to figure out how I wanted to draw the time well or portal. Again the main problem was the limited space. Originally I was trying to get both the WWI soldiers and the dino on the same page, in some kind of swirling layout, **(FIGURE B)** having Heather fall through the portal and land in WWI, with soldiers alerted to her when they see her "jump" in. She'd land on a dead soldier and recoil as bullets whiz by, as the British soldiers, thinking she's a German soldier, advance on her. Panicked a bit she jumps again to fall back further in time as the timebelt is damaged, and lands with the dino.

A lot for one page, and as you can see, with the Marvel Style of plotting I am doing a lot of writing here, plussing the script, adding sequences. This is what I love to do, as it gives me a free range to direct the scene. But it was too much to do on one page as you can see in my rough layouts, so I had to cut and combine ideas. I would have loved to stretch this over a double-page spread, or maybe even have a splash of just the dino.

In the end I came up with the solution of having her

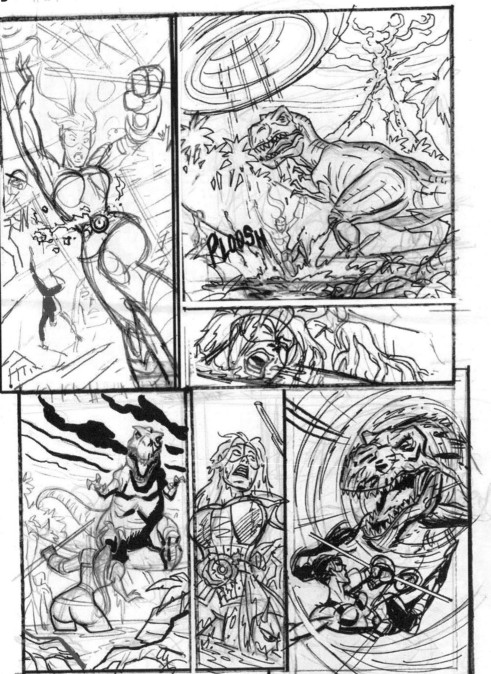

E

Sometimes as in FIGURE (E) I may do a few rough drawings of figures separately to work out possible poses or drawing problems.

Luckily I had a good model on hand in the studio for my dino reference, my T-Rex toy from Jurassic Park (FIGURE F). It's a great model and really came in handy for drawing good old T-Rex.

F

falling through the time-stream, sort of like the strata of rock you see exposed in a place like the Grand Canyon. As you go down through the layers of rock you go back in time, and the separate bands (time) are clear. This way I could show an astronaut, the war, the Sphinx, etc., indicating she was falling through time and get some nice sexy figures in here as well. I also did this because everyone knows dinosaurs are way cooler than soldiers! I adapted some of my original ideas from my first batch of roughs into my final layout. **(FIGURE D)** One thing I was keeping in mind here was that color was going to make a big impact on this page, and in the beginning I decided to do very little rendering or turning of form and go for a cleaner look and allow the arrangement of blacks and colors to carry the day. This is my favorite page out of the whole job and the first page where I really felt I was finally starting to click and get what I wanted.

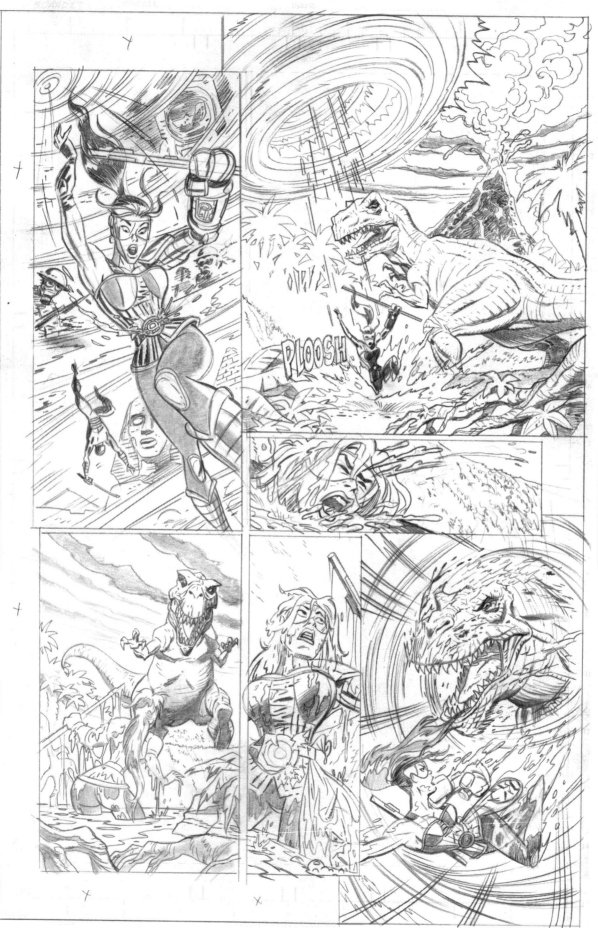

**LEFT:** The final pencils for page 3. I felt here I was getting more of a handle on Heather's personality. In the past, it's sometimes taken a few issues to feel I know a character. Sure, some characters like Batman or the Hulk I already feel I know from reading or watching their comics or cartoons for many years. I think of them as real people, like an uncle or friend, so I can make them act on paper.

If I can develop that intimacy with a character, feel like I know them as a "real person," I will better be able to communicate that to the reader and make the character seem real, believable to them.

I will say, however, seven pages is not enough to fully develop a new character's personality, but it's like having a good first date. You leave with a good feeling and look forward to a second date.

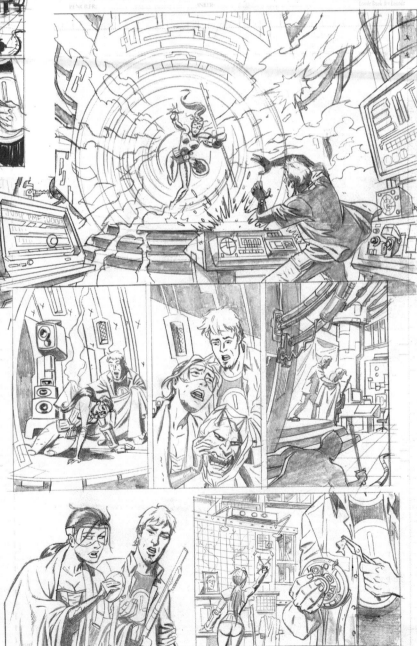

On page four we meet Henry, Heather's brother. I wanted to show how close they are as brother and sister, and that he's the tech guy and she the adventurer, but she couldn't do it without him. So their gestures are important here, I wanted this page to read like a silent movie, without words, so the gestures and staging have to be really clear.

Also this page was a big effects page and a page where I had to show some of the home base, lab, and time-jump machines. My idea was to do something design-wise that would work for a movie or TV show, since Danny and I would also try and pitch our idea to Hollywood through our own connections. I also added a small picture of her father in panel six, which readers may pick up on later. I also worked to make the ninja's silhouette in panel four read, yet keep him mostly in shadow.

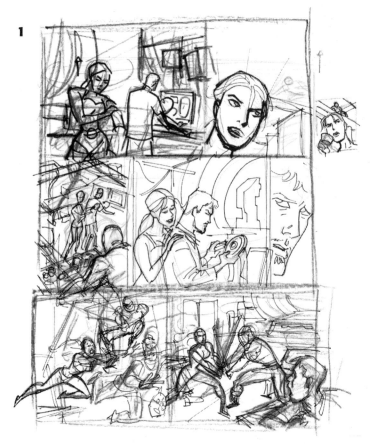

**1**

This page went through a lot of changes and editing, and probably took the most time to lay out because I had a lot to include. I needed to show Heather recovering and talking about her mission, Henry doing his tech thing repairing the jump-belt, and the ninja sneaking and attacking. I also wanted to get a nice close-up of Heather reflecting on her trip and being resolved to find her father despite Henry's doubts.

(FIGURE 1) This was my first pass on the page and I wasn't quite happy with it and did another rough (FIGURE 2) which I e-mailed to Danny. I

**4**

was pretty happy with this, but Danny felt the action was more important and wanted bigger figures on the ninja attacking. He could cover the exposition in fewer panels allowing me to "blow-up" the action panels. I'm still on the fence about this but I did a real quick drawing in Photoshop over my layout (FIGURE 3) and sent that to Danny and he liked this better.

(FIGURE 4) A study of Henry for panel one.

(FIGURE 5) This is the final pencils which combined elements from all of my previous layouts.

**2**

**3**

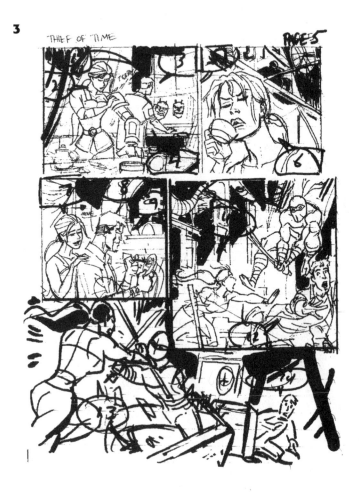

5

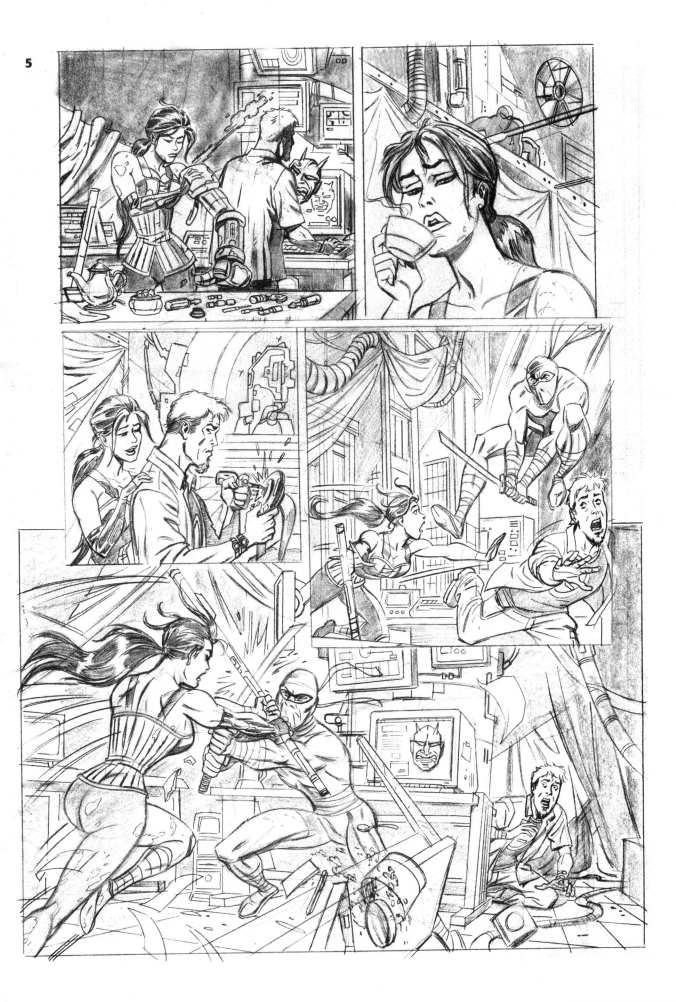

Thief-Plot-v4-Fingeroth.rtf

**PAGE SIX:**

• "Get him out of here, Heather! This equipment can't be replaced!"

• She sets the time-dial as the warrior swings at her, barely missing her as she athletically flips out of the way. But he smashes the mask. Shit. They needed it.

• She grabs him, starts to set the dial. "Time to take you back home, loverboy."

• He breaks free, they battle inside the lab, Henry hiding behind machinery. We understand that bravery is not his strong suit.

• Heather pushes the buttons and she shoves the ninja (or whatever) through the opening time portal. As he goes, he smashes a component on the controls.

• At the last second, he grabs her and is pulling her through with him. Ancient Japan is seen through the portal.

**2**

Above **(FIGURE 1)** is Danny's plot for page six and to the right **(FIGURE 2)** are my initial thumbnail breakdowns for pages six and seven. I laid out both pages at the same time as I wanted to make sure I could get the end of our comic to flow right for the cliffhanger. You can see I was working out the gesture poses on the ninja and Heather, trying to get good, clear, strong gestures and to make sure they read well as they overlay each other. I was also playing around with how to choose my shots. Do I want a medium shot, a close-up?

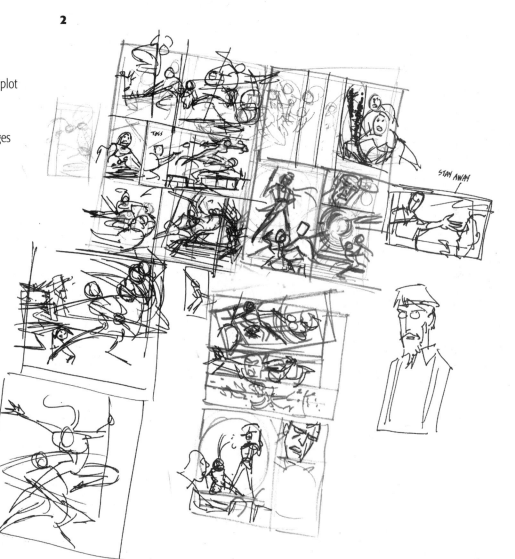

(FIGURE 3) I decided to do most of the shots as medium shots to clearly show the action, and to add an inset of Henry in panel three to keep him in the action. In film this would be a quick cutaway shot. To me that is what an inset panel is, it's almost a cutaway shot as you are showing two points of view in essentially one panel; you want the readers to read both panels as happening at the same time or to indicate that the person in the inset panel is watching the action happening in the larger panel it's set into. (FIGURE 4) The final pencils for page six.

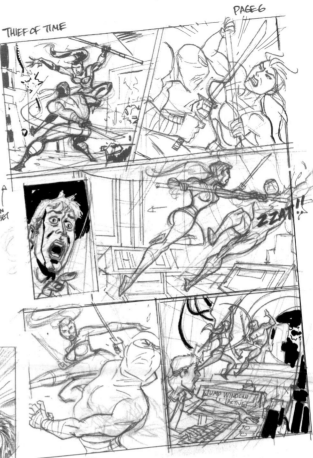

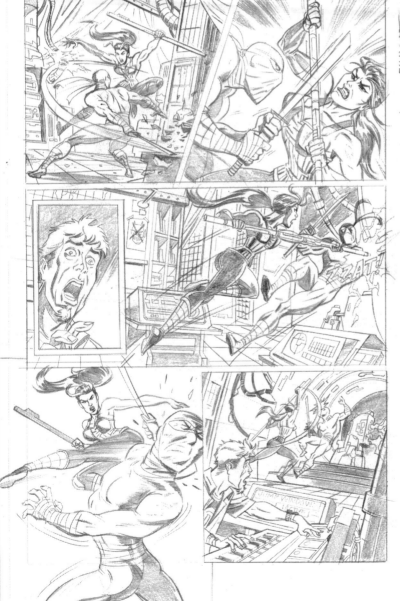

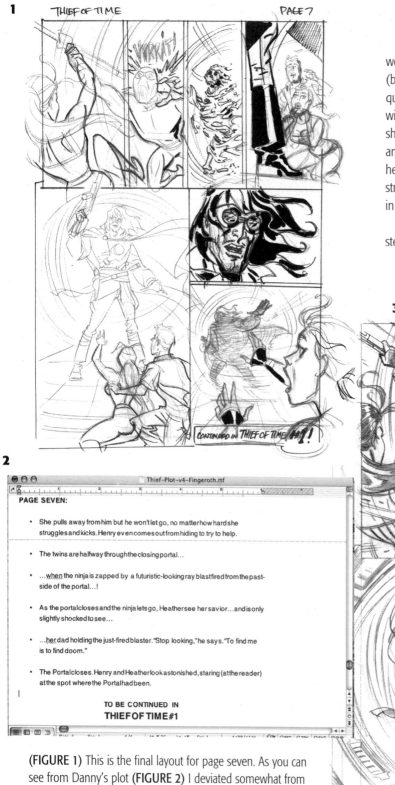

We go in really close, putting the camera in a very dramatic angle, a worm's eye view, to see the father's boot and the kids' reaction to him (but he's mostly off-screen to keep the suspense). This creates a question/tension in the reader's mind which is paid off in the big panel with the dad looming over the two kids, so we pull out for an establishing shot. The sweep of the father's cape leads us to his close-up in panel six and the flow of his hair leads us to Heather's right arm, which leads us to her face. We pull back from the father as he fades away in the time stream. I was also conscious of the fact I needed to arrange the elements in the panels to allow Danny plenty of room for dialogue and captions.

(FIGURE 3) The final penciled page for our comic. Now the next step... on to inking!

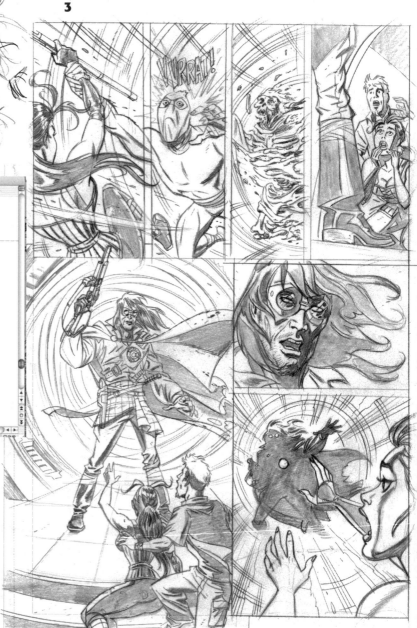

**PAGE SEVEN:**

- She pulls away from him but he won't let go, no matter how hard she struggles and kicks. Henry even comes out from hiding to try to help.

- The twins are halfway through the closing portal...

- ...when the ninja is zapped by a futuristic-looking ray blast fired from the past-side of the portal...!

- As the portal closes and the ninja lets go, Heather see her savior...and is only slightly shocked to see...

- ...her dad holding the just-fired blaster. "Stop looking," he says. "To find me is to find doom."

- The Portal closes. Henry and Heather look astonished, staring (at the reader) at the spot where the Portal had been.

                    TO BE CONTINUED IN
                    THIEF OF TIME #1

(FIGURE 1) This is the final layout for page seven. As you can see from Danny's plot (FIGURE 2) I deviated somewhat from what he wrote. I kept Henry working the controls as Heather fought the ninja, only to have him come up to her so he can be with her as they look up and see their father. I also decided I wanted the ninja to disintegrate after the laser/energy bolt hits him. I figured it was some sort of time gun. On the design of the father I wanted him to wear an eclectic assortment of clothes and such that indicated he has been through various eras in time. This is what I call an in-out page.

# INKING

The most fun on any job after the layout, for me, is the inking stage. At this point it's all smooth sailing. I covered a lot on inking in my article back in *DRAW!* #6. On the *DRAW!* DVD I also go into detail on pens and brushes and how I use them. The screen grabs here are from the *DRAW!* DVD chapter on inking. On the DVD you will be able to watch me ink a page of the *Thief of Time* comic from beginning to end.

I want to stress again that inking is drawing in ink. The ink drawing has to be as good as the pencil drawing. Despite the joke in the film *Chasing Amy*, inking is not tracing.

Before I ink a page I often warm up by doodling with a pen or brush directly on sketch paper or in a sketch book. **(FIGURE 1)** I may do this for a half hour or maybe even an hour if I'm having fun. Like a musician warming up with his instrument, my goal is the same: to get the juices flowing.

I usually start on a page by starting with some background inking, but sometimes if I am warmed up and ready to go, I pick up the pen and have at it and start with some figures. I generally do pen inking first **(FIGURE 2)** then go back with a brush and heavy up a line or fill blacks. Sometimes I may ink almost everything with a brush if I feel it calls for it. Again, my approach is always open and interpretive.

My whole process is very organic and flexible and when I ink a page, first I look at it and decide where I'm going to use a brush versus using a pen. I think the brush is great for organic things like hair. I also love to ink using the Rotring Rapidoliners. They are disposable rapidographs which come in various widths. My favorite is the .35. I love inking with these and can get a great variety of line from them from practice.

I sometimes have two bottles of ink: One for the pen which is thinner and one for the brush which I often leave open. By leaving it open some ink evaporates and it becomes thicker, denser and covers better with a brush. If the ink gets too thick I just add a little water.

I also will use templates when needed and suggest that any artist have a good set of ellipse templates, circle templates and French or ship curves. I also like Sakura Micron and Copic markers and often use the .02 or .03 for inking small faces and details. But always wait at least 20 minutes before erasing the page after using them as they will smear badly if the ink isn't dry, especially on plate finish paper.

**1**

## TOOLS OF THE TRADE

A

B

C

D

**A) KOHINOOR RAPIDOGRAPH.** Technical Pens or any technical pen 00 or .35.
**B) THE WINSOR & NEWTON SERIES 7 No. 3 sable brush.** The tough yet supple hairs allow great response and delicate control.
**C) THE SAKURA PIGMA MICRON.** These pens are great and the tips last a pretty long time. The ink is waterproof and fade proof. Just let the ink dry at least 15-20 minutes before erasing to avoid smearing.
**D) THE HUNT 102 PEN.** The industry standard. It's point is fairly flexible and allows a snappy thin-thick line.

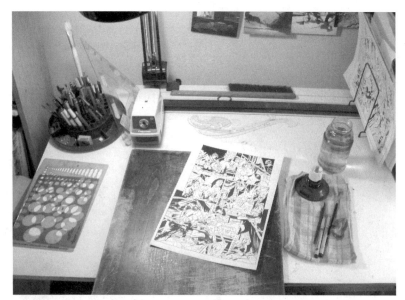

My inking set up is pretty basic. I have a bottle of ink for my pen and brush and have a Higgins drawing ink bottle and stand with pen rest across the front. I bought the stand off of eBay and it's great for preventing the accidental spilling of your ink bottle. I also have an old rag, and a jar of water. I don't use much whiteout these days since I scan that art into the computer, so I fix my mistakes and do corrections in Photoshop. I use Higgins ink. I have a fairly large stockpile of it that I bought years ago. If I find art supplies I like, I will buy a large quantity of it as I don't want to run out, and too often in the last 15 years companies have either gone out of business or changed their formula. I ink and pencil using a lap board which saves on my back. This old board was a gift from Al Williamson and was one of the boards he used back when working on his EC jobs in the '50s.

These images grabs are from the inking tutorial on the *How to Draw Comics* DVD. When I first begin inking I usually start with ruling backgrounds and warm up on them. I sometimes will ink on several pages at one time and switch back and forth. After the page gets too wet, set it aside and work on another one while the last one dries. I usually have a fan running in the studio as the air circulating helps the pages dry faster.

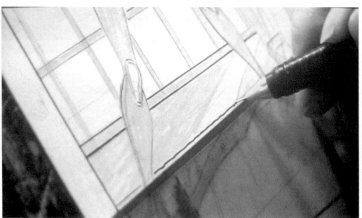

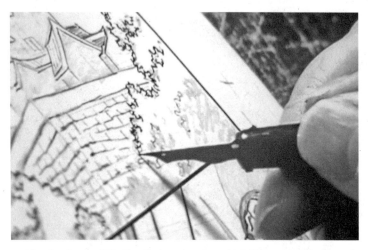

After the figure of Heather is done I go in and ink the masks with the Rapidoliner. Sometimes I switch back and forth between the pen and the Rapidoliner depending on what effect or type of line I am going for. I choose my inking tool based on the type of line I want to make.

Next it's time to whip out the pen. On this job I used a Hunt 102 Crow Quill pen. The 102 is pretty much the industry standard pen nib and it's fairly flexible and you can get a good thin-thick line. If you are lucky and get a really good nib it will last for several pages before it snaps and breaks.

I move through the entire page and do all my pen work first. Some small work I do with the Rapidoliner or a Micron Pigma, but I use the pen for the more organic figure work as it gives the line a nice thin-thick snap, and is great for doing a wide variety of textures. My suggestion is to do a lot of direct drawing with the pen you find most comfortable so that when you are inking you are confident. You must be confident when inking!

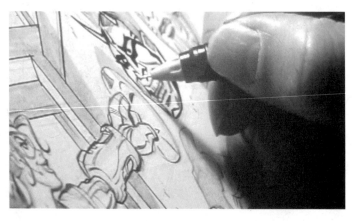

**1**

Once the pen work is done I make sure the page is dry so I don't smear the ink, and then pick up the brush and go. I start laying in the blacks. I usually use an older brush without as fine a point to fill in large areas of black as that much ink can be hard on a good brush. So don't throw away those old brushes! I save my new or good brushes for the detail inking.

**2**

The brush is great for doing scrumbly type inking on things like trees, etc. A good technique or way to think of inking trees is to think of it as a high contrast photo which knocks out all the detail except for the black-and-white patterns.
**(FIGURE 3)**

**(FIGURE 4)** Below I go in and add feathering and textures and fill in blacks on the masks and figure.

**3**

**4**

# LETTERING

The last big step of producing the *Thief of Time* comic (after coloring–see pages 65-68) is lettering the pages. Ideally I'd have preferred to have a real letterer doing the lettering on the actual pages, but like most modern comics I work on, there just wasn't the time.

I prefer the lettering on the original art so I can adjust the position of figures and the compositions once the lettering is down on the board. Sometimes you may want to slightly move an element like a head or arm. Lettering must be taken into consideration as a compositional element within the borders of each panel and as a design element which leads your eye from panel to panel and across the page as well as effects the composition of the panels it is in. They effect the timing or speed at which the reader reads the comic page through the density of copy, number of balloons, and placement. I also like to have my originals with the lettering on them for aesthetic purposes after they have been published.

I am lettering the pages in Adobe Illustrator 10. Now while I was finishing up the pencils and the inks, Danny was doing the final script. Once Danny finished the script in Microsoft Word he e-mailed it to me. He also faxed me copies of the pencils with the word ballon and caption placement. The balloons and caption boxes are numbered to correspond with the captions and dialogue on Danny's script. **(FIGURE 1)**

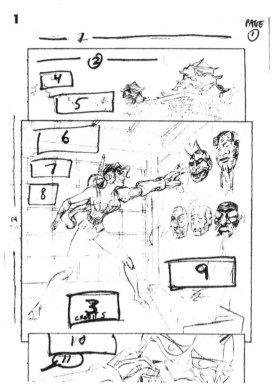

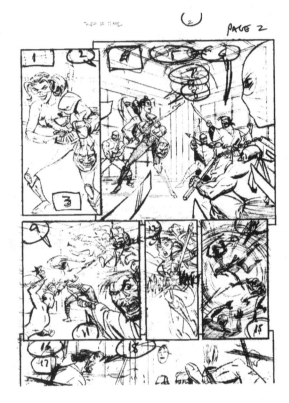

**STEP 1)** I open Danny's script in Microsoft Word, then open Illustrator and import the page I'm going to letter in Illustrator. I set the page size at the standard comic-size page (6.625" x 10.187").

**STEP 2)** I go through the page and roughly place all the balloons and dialogue and caption boxes, matching where Danny indicated on the faxes. I do this quickly as I know I can come back later and adjust their specific size and shape. I can also adjust the color of each balloon or caption box when it's selected by using the CMYK sliders. I decide to keep all my dialogue boxes a light yellow. I set the stroke at 1 point; this keeps the black line or frame around the balloons at 1 point in width. Again things like this can be adjusted to suit your tastes and to create different effects.

**STEP 3)** I create a new layer in Illustrator and name it **Lettering**. I save my doc and then I copy the type or dialogue from Word and paste it into Illustrator. I'm using the font called AstroCity and I set my type at 8 pt. with 8 pt. leading. Danny indicated in the Word file which words he wants bold and italic and I match them by selecting the word, and then in the character menu choose the bold typeface of AstroCity, which has a bold and italic version. Using the paragraph menu I select the **CENTERED** option, then using the type tool adjust the type to fit nicely and then do adjust the ballon to fit around the letters. I like the negative space around the letters in my word balloons tight but to too tight, or the words appear cramped.

**STEP 4)** To crop word balloons so they will become flush with the panel borders I first draw a box by selecting it from the marquee tool. I draw the box over the part of the balloon I want to crop. Then I hold the shift key down while the box is selected and then click on the word balloon. Now both are selected. In the **PATHFINDER** menu I then select the second box in the **SHAPES MODE**. This clips away the part of the balloon I don't want. **(FIGURE 5)**

I repeat Step 4 again to clip off the top of the balloon to make it flush with the panel border. I continue through the rest of the page and keep repeating these steps with all the balloons I want to crop flush with a panel border.

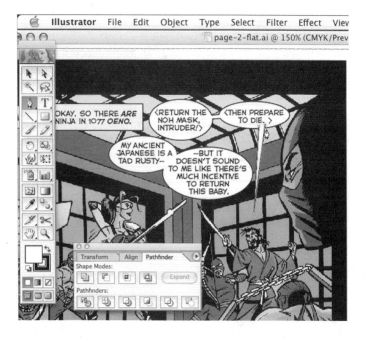

**STEP 5)** Now I draw the balloon tails with the pen tool.

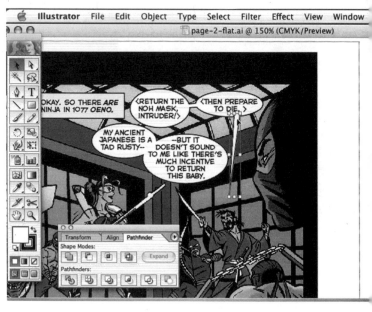

**STEP 6)** Using the selection tool I can now adjust the tail as I want, or even draw one freehand with the pen tool. I also go and draw the bridge tail between the balloons to join the dialogue. I merge the balloons that are Heather's together by selecting both, then clicking the first box in the **SHAPES MODES** menu.

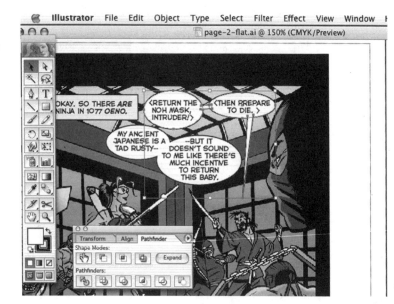

**STEP 7)** I join the balloons and tails all together again by selecting them all (by holding down the Shift key) and clicking on each one with the selection tool and then clicking the first box in the **PATHFINDER** menu. Now each character's balloons and connecting balloons are joined as one shape.

I go through the rest of the pages repeating these same basic steps until every page is lettered. I save each file as an Adobe EPS file, which I will open, flatten and save in Photoshop as 300dpi CMYK TIF files. I will import these TIF files into Quark Xpress which I use to assemble all of my books, including *DRAW!*, for printing. I do all of my sound effects by hand as I prefer to place them in the art when I'm drawing the pages.

# QUARK

The last major step for me in creating the comic and getting it ready to send off to my publisher John Morrow, is for me to assemble the comic book in QuarkXpress, the layout software that's pretty much the industry standard for prepress. After he does tweaks and the issue is proofread, John sends all the files via FTP over the Internet to the printer. You can read all about what John has to do in his article elsewhere in this book. I created the *Thief of Time* logo in Photoshop CS and later imported and placed it on the cover in Quark, along with all the cover copy.

**STEP 1)** I create a new document in Quark with the proportion of the printed comic: 6.625" x 10.187". I had saved all of my final inked pages as EPS files in Illustrator 10 and then opened them up in Photoshop CS and converted them into 300dpi TIF files in CMYK. **(FIGURE 1)**

## New Document

**Page**
Size: Custom ▼
Width: 6.625
Height: 10.187
Orientation: [portrait] [landscape]

**Margin Guides**
Top: 0.5"
Bottom: 0.5"
Left: 0.5"
Right: 0.5"
☐ Facing Pages

**Column Guides**
Columns: 1
Gutter Width: 0.167"

☑ Automatic Text Box

[ Cancel ] [ OK ]

**STEP 2)** I insert the number of pages I'll need to contain all the pages for the comic. **(FIGURE 2)**

**STEP 3)** Using the Picture Box tool I create a picture box on each page and drag it out to fill the entire page. Next under the file menu I select **IMPORT IMAGE** and

## Insert Pages

Insert: 7 page(s)
○ before page:
● after page: 1
○ at end of document

☐ Link to Current Text Chain

Master Page: A-Master A ▼

[ Cancel ] [ OK ]

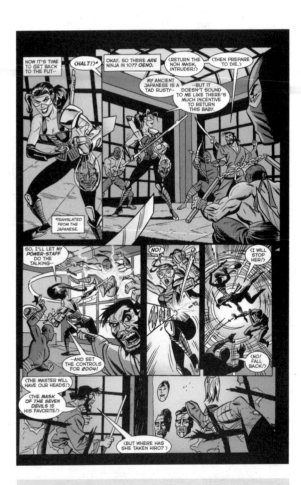

Here's the finished page 2 of the story, with all the lettering elements assembled.

**3**

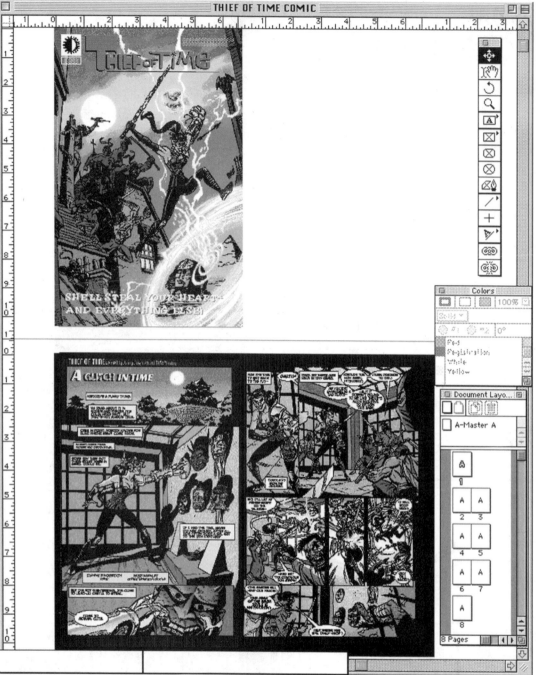

in the browser window I select the comic page to be imported. I have all the final art assembled in a folder on my hard drive. I may have to slightly reduce or enlarge the images to make sure I bleed all the borders except the center border (between two pages on the spine). I need at least 1/8" bleed to give the printer enough room to trim the book. I repeat this process on each page until the entire book is laid out. **(FIGURE 3)**

I go in and place the cover logo and all the cover copy. I tweak the type and can create a custom color in the **EDIT** menu under **COLORS**. Quark is a deep program and it allows you to do a lot with color and type. I'm far from being an expert with Quark (as my patient and saintly publisher John Morrow will tell you), but I do know it well enough to assemble this comic, as well as *DRAW!*, along with the help of John and Eric Nolen-Weathington (TwoMorrows'

trusty production assistant).

At this point the book is essentially done for me. I select **COLLECT FOR OUTPUT** under the file menu which is a great feature in Quark that allows you to create a single folder, name it and put all of the images and Quark files for each job in one place. You have to include any fonts you use as well; make sure you have both the screen font and printer font. The last step is to stuff the files and FTP them to the TwoMorrows server.

So there you have it, my complete creative process on creating a comic book. You can also follow along on the *How to Draw Comics from Script to Print* DVD. With this info, you should be able to go out and create your own comic!

**—Mike Manley**

# Quick Notes on Coloring

The main objective of coloring in a comic to make the artwork attractive, dramatic and help the art set the mood or tone, help the storytelling like a movie soundtrack does.

The first thing the colorist must be concerned with is clarity, to separate the figures from the backgrounds and make them "read" or stand out. Here in **FIGURE A** you see the black-and-white artwork ready to color. The first thing I do is mentally study the drawing and see where the main light source is coming from (here it is the whirling portal) and how the figures play against the background.

The colorist achieves the separation of figures, foreground, middle ground and background elements, mainly by the use of contrast and warm colors against cool colors. **FIGURE B** shows how I broke the drawing down grouping figures into the three layers. F is the foreground, M is the middle ground and B is the background

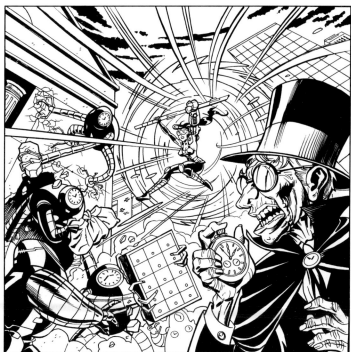

**FIGURE A**

Warm colors tend to come forward and attract the eye while cool colors tend to recede. Super-heroes for the most part have brightly colored costumes, which makes the separation fairly easy if you use muted or duller colors in the background. Overuse of colors, modeling and Photoshop tricks usually result in muddy, dark coloring. My tastes tend to run to simpler modeling and letting the artwork, the linework carry the day. I dislike the dark, muddy coloring so often seen in comics today.

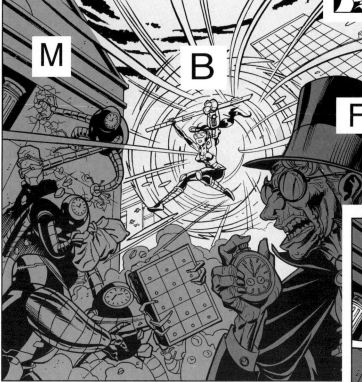

**FIGURE B**

Here I boldly blocked in colors to help separate the figures, and I may go in and change them later.

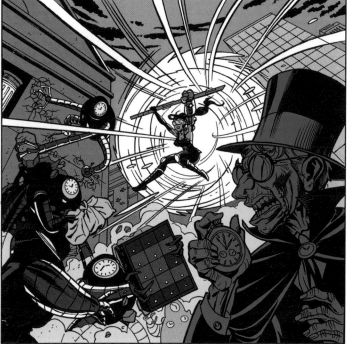

It is also important to remember that the colors you see on your computer screen will be brighter than they will be on paper. They are pure light, not ink on paper. An important step before coloring a comic is to calibrate what you see on the computer screen image to as close as you can to what you see from your printer. It's best to run a few test examples to make sure what you see on-screen in the RGB (red, green, blue) spectrum matches the CMYK (cyan, magenta, yellow, black) 4-ink color process that all full-color printing uses. *—Mike Manley*

## The final illustration

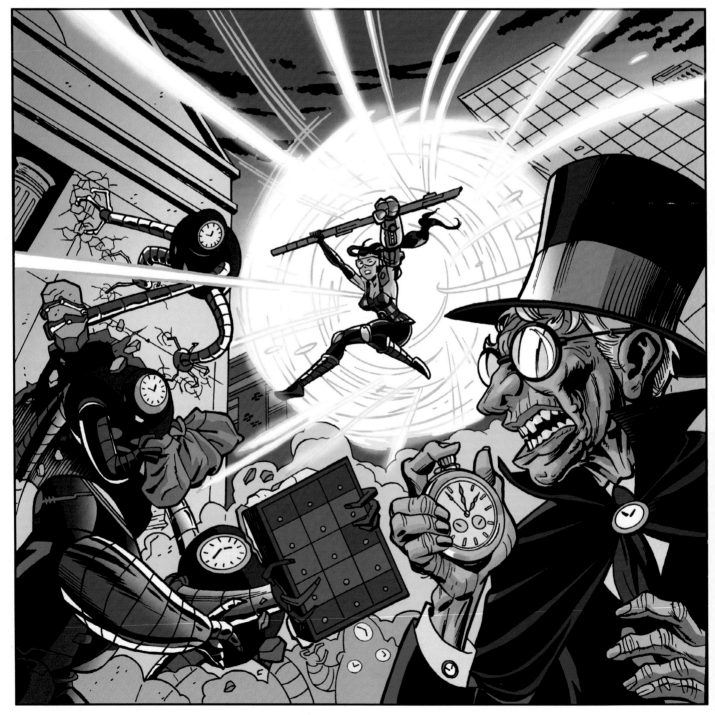

# COLORING

I work in layers when coloring in Photoshop. I know some colorists and artists work in channels. I've never done that. I've always worked in layers. Maybe it's because that's just the way I learned to color when I started using Photoshop years ago. It's also similar to animation where you have the cel and the background, something I'm very familiar with from working in animation.

My process is pretty straight forward. I don't do any color guides or keys and just work straight ahead. I can really see the color I want in my mind and it's really an intuitive process for me. However, for some of you less experienced, I do suggest doing quick color guides either in markers with a photocopy of the page reduced to printed comic size, or a quick rough color in Photoshop. The main thing is to have good values and contrast in your coloring. Warm against cool, etc. Limiting your palette is also a good idea. If you have the values too similar, the coloring will be flat. A good way to see if the values are good is to convert the image to grayscale in Photoshop. If you find the page is very flat, the grays too similar, that means you'll want to push the values in your color art.

I suggest getting a few books on color and studying the color chart, learning about value as well as complementary colors, etc. In my experience color sense is intuitive, personal, and some people just have a great natural sense of color, like a musician having a natural sense of timing.

**STEP 1)** I scan my page in Photoshop at 600dpi as line art, not grayscale. Once the page is scanned, I convert it to grayscale and clean it up and fix any stray lines and dirt, smudges, etc. Then I save it at 300dpi as a grayscale TIF file. My scanner is a Microtek ScanMaker 9600XL. I still scan in OS 9 as a new driver for my scanner hasn't been made that works with OS X on my Mac.

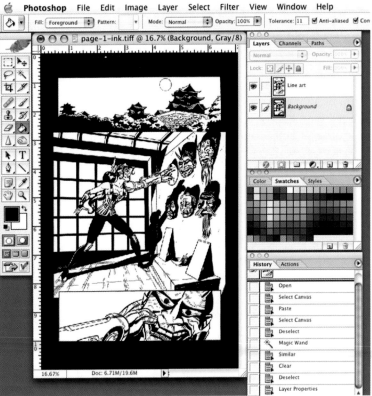

**STEP 2)** After I convert the image to grayscale, I select the entire image, and copy and paste it onto a new layer. Next I select a small trapped area of the white with the magic wand (**FIGURE 2**) and in the menu under **SELECT** choose **SIMILAR**. This selects all the white area in the image. I hit **DELETE** and all the white is gone, leaving only the black line. Layer one is now essentially like an overlay I can see through and I'll color on the background layer underneath.

**STEP 3)** I convert the image to **CMYK** under **IMAGE>MODE** on the menu.

**BELOW: A screen grab from the *DRAW!* DVD showing Mike using the paintbucket to fill in the basic colors on the page.**

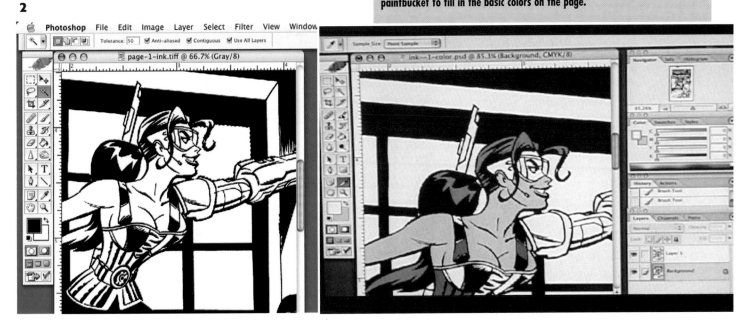

CMYK is the way all four-color artwork is separated for printing. Now I'm ready to start coloring since every color in the four-color printing process is a mixture or Cyan, Magenta, Yellow and Black.

**STEP 4)** I go though the page and using the paint-bucket I fill in some big basic colors. This would be like blocking in the middle values in a painting. I can go darker or lighter or even change the color all together later, but at this stage I want to basically go over and block in the entire page.

After I am satisfied with the block-in stage, I start going in and adding detail to the color, adding some shadows on the form, doing slight blends and highlights. My approach to coloring or modeling the form is the same in Photoshop as it is in painting. Highlight, middle value and shadow. Sometimes a second shadow tone, like in an animation cel, is all you need to pop a figure forward and give it dimension. I work back and forth either using the magic wand or the lasso to select areas to color. I use a Wacom tablet and the stylus to color the pages. I use the large 9" x 12" tablet as it allows me more freedom of movement.

### SUPPORT YOUR LOCAL CARTOONIST

My big issue with most colorists working in comics today is that the coloring is going against the artwork, obscuring the art and often the detail the artists labored to draw for the reader to appreciate. The colorist is often lighting the form against the direction of light indicated by the artist. I also dislike a lot of airbrushing. I think it's a great tool if used sparingly, but too often it's overdone and the art looks greasy, slimy. So my motto is "simple is better."

**(FIGURE 3)** This is an example of what I was talking about when making sure your coloring has good values. The figures and backgrounds must separate and "read" well against each other.

On the *DRAW!* DVD, *How To Draw Comics From Script To Print,* you can watch me as I go through all of these steps and more live, as I color the first page of *Thief of Time.* I also show you how sometimes I go back in and slightly adjust the hue of the page or panel by choosing **HUE** and **SATURATION** under **IMAGE>ADJUSTMENT** on the menu. This is a great filter to use to cast the entire image warmer or cooler. I often use this filter, especially in a night scene.

When adding lighting effects like the glow from the portal **(FIGURE 4)**, I will do that on a separate layer, sometimes having several layers for each page.

The last thing I will say about coloring is that it is really responsible for the emotional mood, like a soundtrack in film. Coloring that detracts or goes against the feel of the scene is like wearing bright colors at a funeral.

**–Mike Manley**

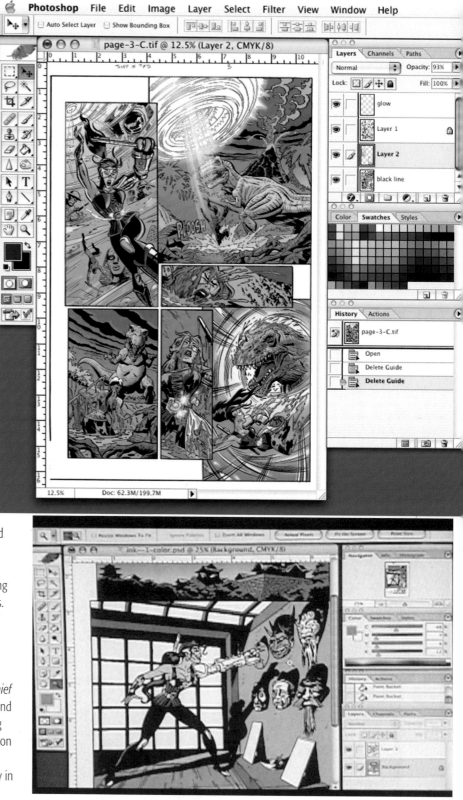

**3**

**4**

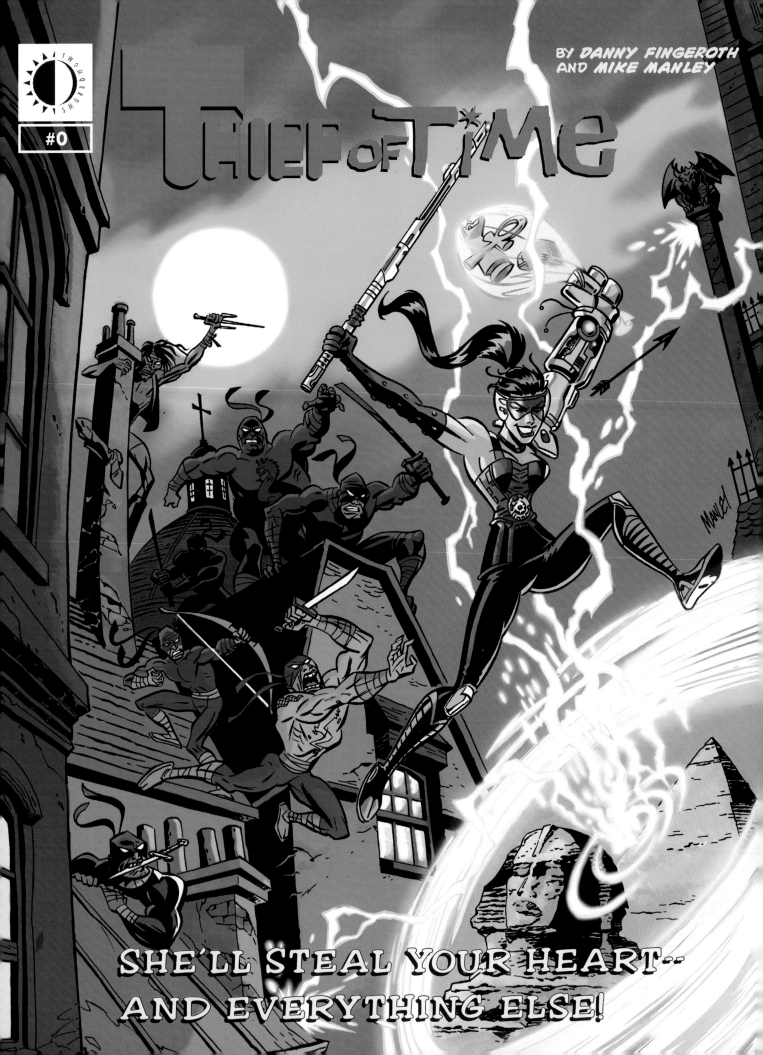

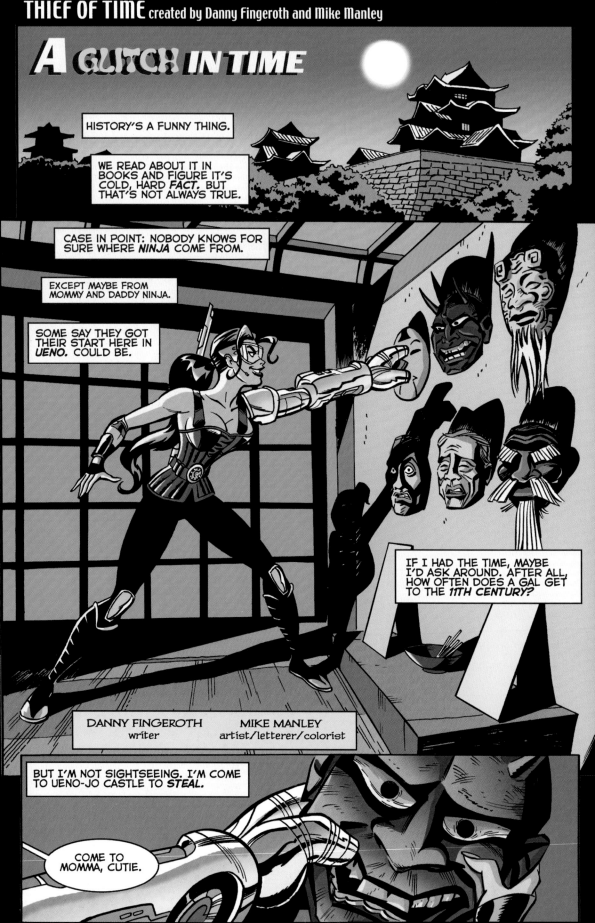

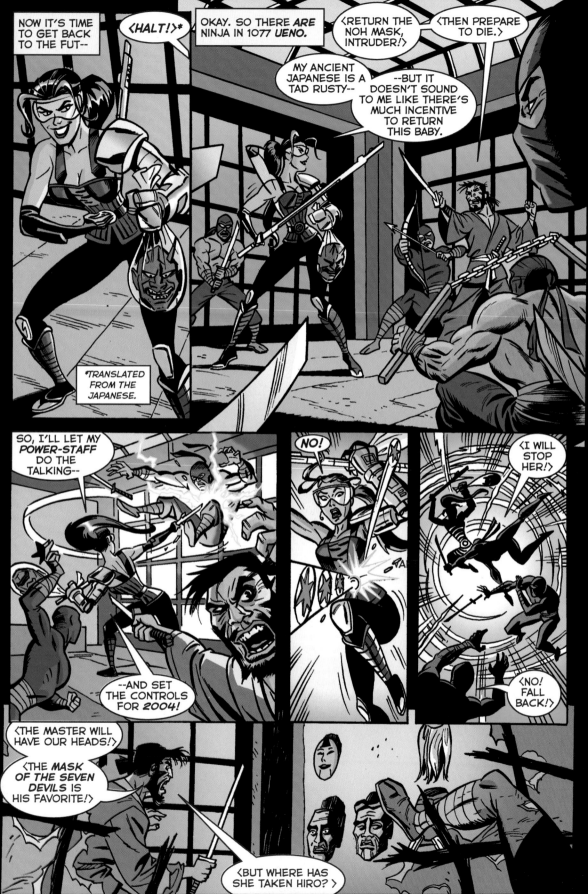

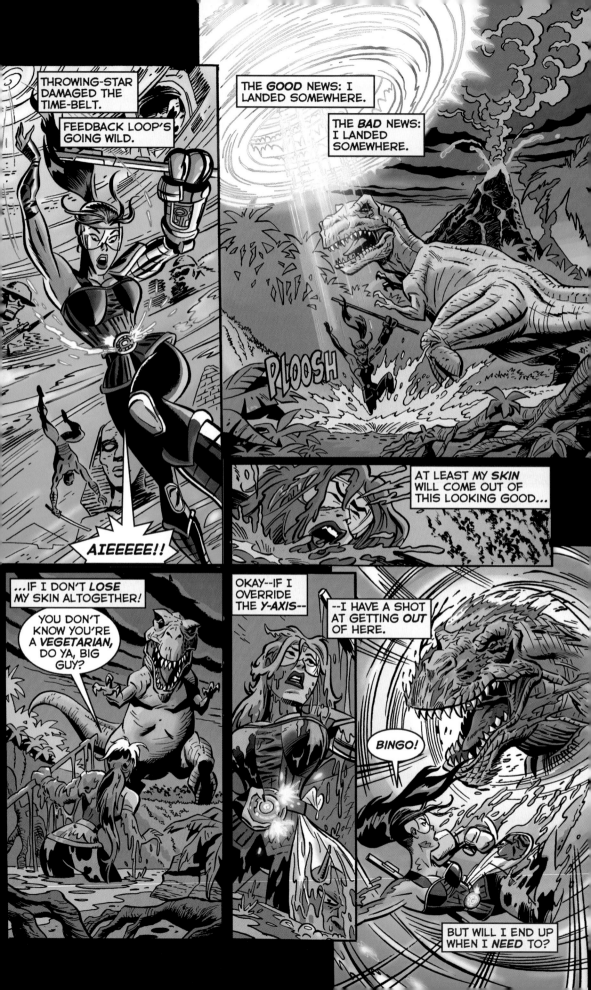

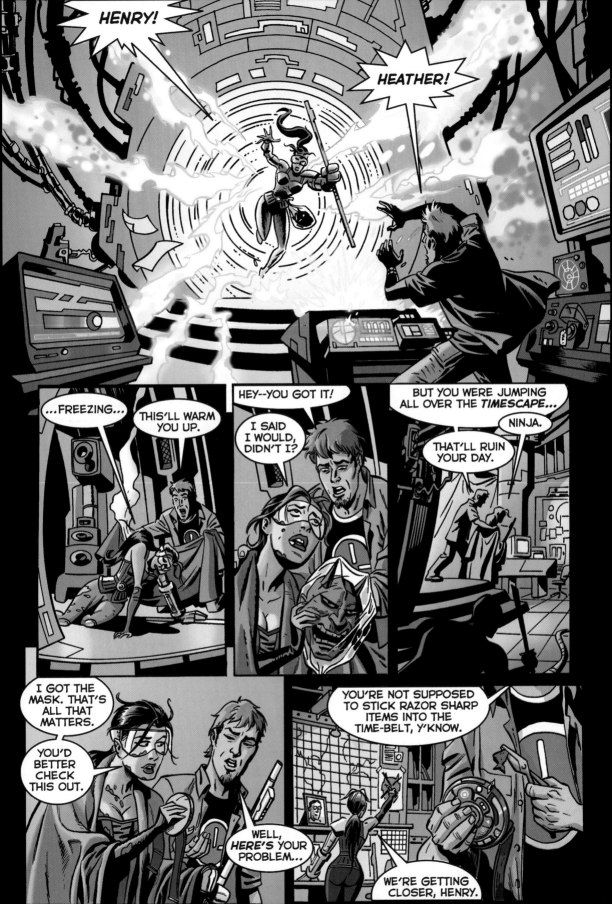

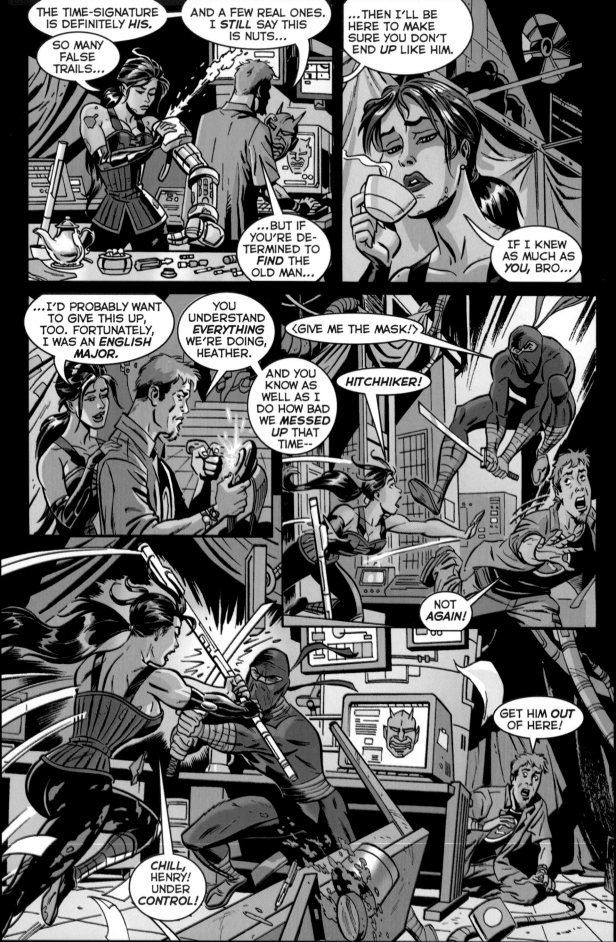

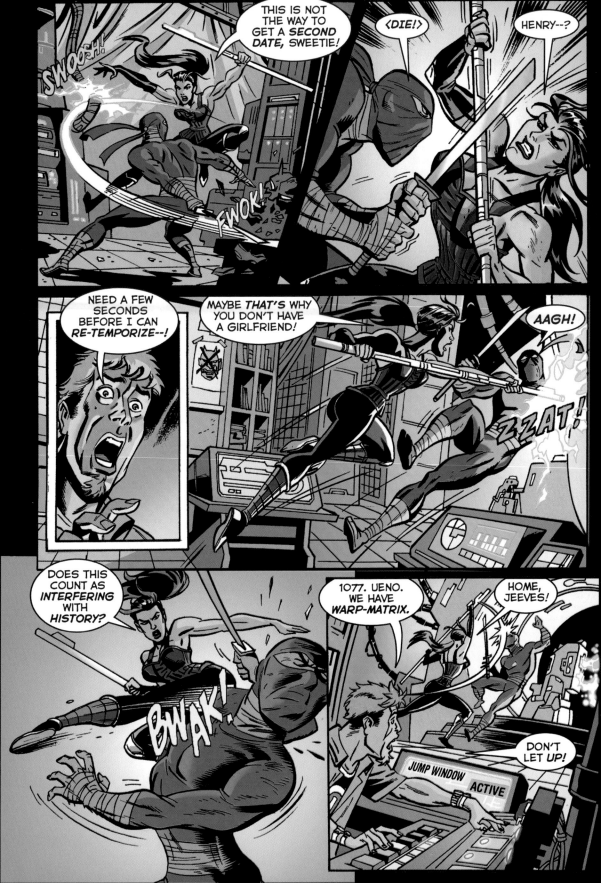

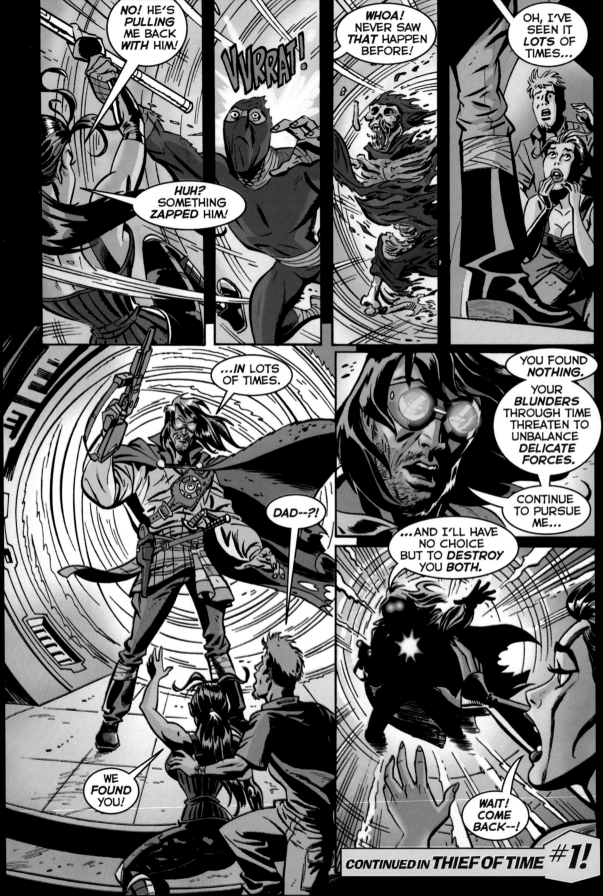

CONTINUED IN *THIEF OF TIME* #1!

# CREATIVE FLASHBACK!

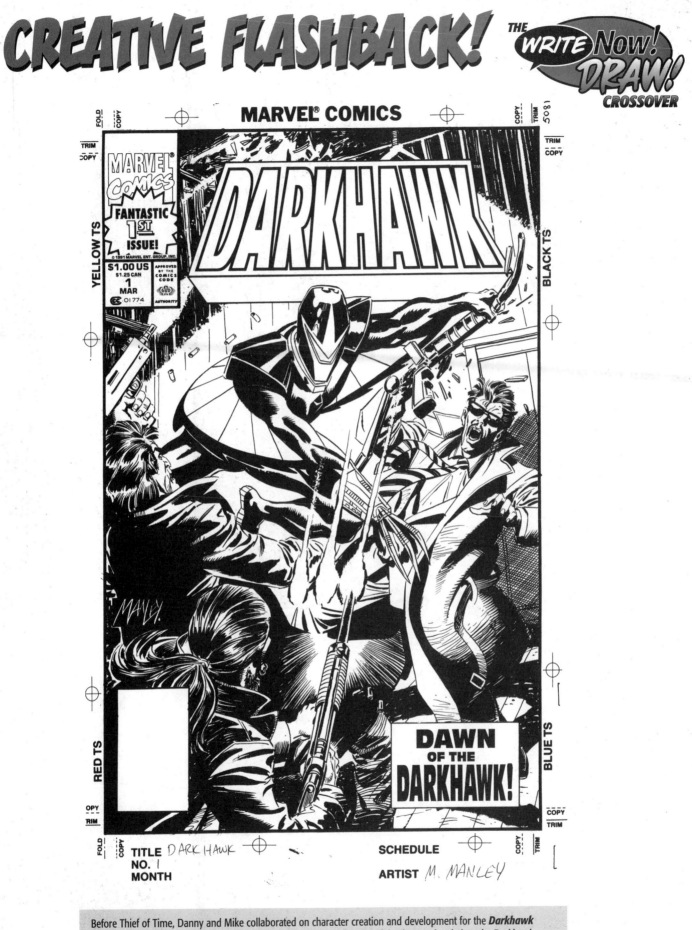

Before Thief of Time, Danny and Mike collaborated on character creation and development for the *Darkhawk* series. In this section we see some of their work from the storyline that delved more deeply into the Darkhawk backstory. [©2006 Marvel Characters, Inc.]

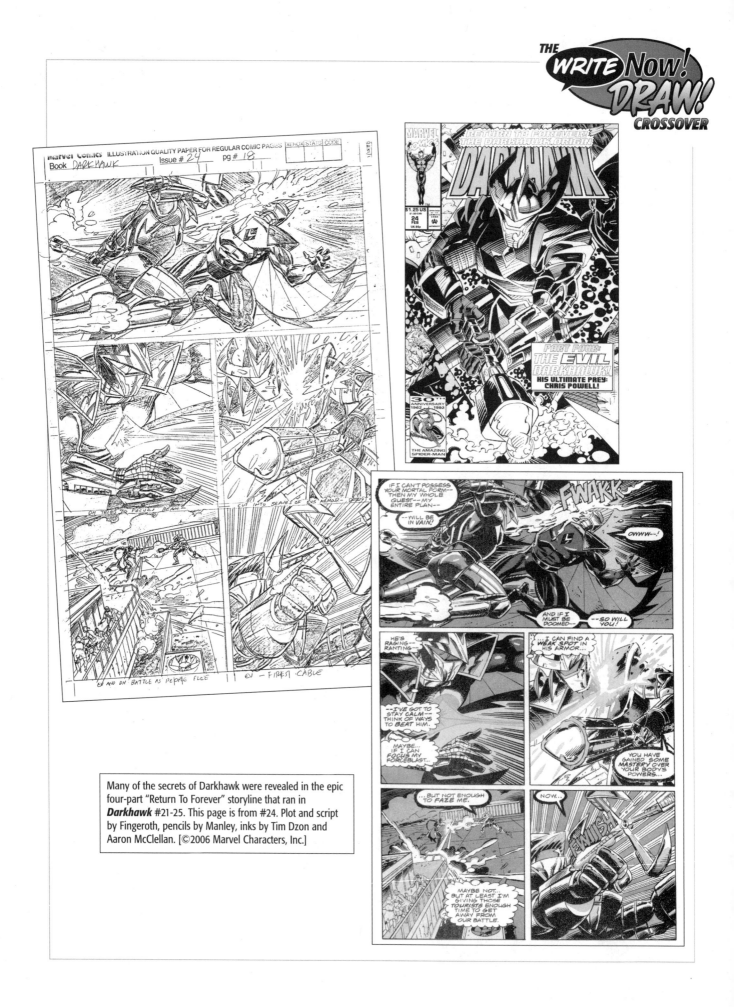

Many of the secrets of Darkhawk were revealed in the epic four-part "Return To Forever" storyline that ran in *Darkhawk* #21-25. This page is from #24. Plot and script by Fingeroth, pencils by Manley, inks by Tim Dzon and Aaron McClellan. [©2006 Marvel Characters, Inc.]

DARKHAWK
BACKSTORY AND MORE: REVISION OF 7/12/92
DANNY FINGEROTH

ULTIMATE BACKSTORY AND MORE: DARKHAWK

MECHANISM OF THE DARKHAWK AMULET AND BODY:

An amulet teleports the wielder and a DH body back and forth, while keeping the wielder's consciousness in place. It also focuses the force-blasts and shields, though they can work to a degree without them. It also works as a "battery" for the body, transforming ambient (solar, stellar) energy into usable form for the body. That's why the wielder weakens as he's separated from the amulet. (When in the DH form, that is.)

An amulet can be used by anybody. That's what makes it a powerful fantasy. You don't have to be worthy or noble or fearless to be a Darkhawk. You just have to want to be one. That means a kid in his backyard or in his room--no matter how lacking he may feel--can feel that he might one day find an amulet like Chris's and and gain that power he's always wanted. If this were not the case, there couldn't be any such thing as an evil Darkhawk. But the existance of evil DH's--or weak ones like Ned--will show just how special Chris is.

If the amulet is ripped from a DH body, it can reattch itself if it's positioned correctly. This is a mechanical process, like waiting for solder to set. That's why it took a while in issue #15. The "contact points" have to be touching for a while.

If the amulet is permanently ripped out, the body's energy can be fully depleted. Then, the consciousness will lie dormant but essentially still there, unless every erg of energy is used up, in which case the consciousness will dissipate. That will render the wielder in effect dead, as his human body will remain in a vegetative state. If the DH body is atomized or disintegrated, the same should hold. Execpt for Chris--who is zapped to the ship in a last saving act by Johnny--or maybe by his own sheer will to live and noble nature.

If the human form is destroyed while a consciousness is in a DH body, would the consciousness survive? Probably not--hence, Bokk's eagerness to find Chris and steal his human body.

Is there a limit to how long Chris (or anyone) can stay as a DH before there are severe repercussions? No. But after a certain amount of time, one starts to progressively go madder and madder. So, when Bokk gets to Earth, he is one crazy dude. One could in theory keep a mortally wounded or ill human alive on the ship forever, but the mind that would return to it would be screwy beyond repair.

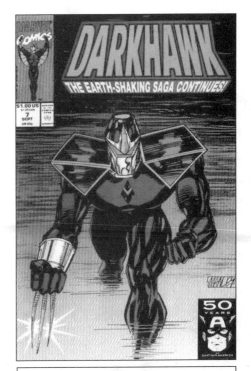

Cover to **Darkhawk** #7, penciled and inked by Mike. [© 2006 Marvel Characters, Inc.]

In a manner not unlike the way the backstory of Thief of Time is developed by Mike and Danny as they prepare the "Glitch in Time" story, the backstory of Darkhawk was developed and refined and fully revealed by them in **Darkhawk** #25.

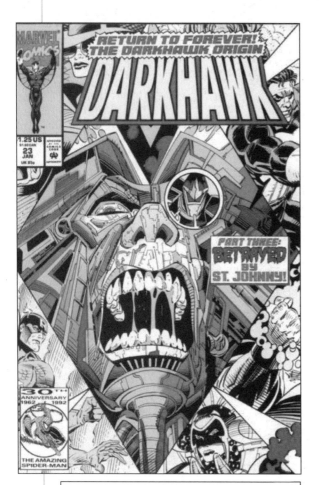

Mike's cover to *Darkhawk* #23. [© 2006 Marvel Characters, Inc.]

Darkhawk's amulet in action, as he transforms from Chris Powell to Darkhawk in the middle of battle. From *Darkhawk* #23, written by Danny Fingeroth with pencils by Mike Manley and inks by Frank Percy, Chris Ivy, & John Lowe. [©2006 Marvel Characters, Inc.]

On these pages, excerpts from the Darkhawk origin-deepening story document are reproduced. Some of the backstory turned into actual story images, as seen in the page from *DH* #25. But all of it is background information the creators knew, relating to what made the series' characters tick, even if some of it was never specifically mentioned in the pages of the comic.

The DH bodies have humanoid-like anatomy because humanoids designed it. (Most of the scientists were humanoid, if not all.) Or because Bokk was humanoid--and he was running the project. DH's feel pain because of a flaw in the design. Though they are (as we've agreed on, right?) living, they are more of a rudimentary form of life--somewhere between vegetable and sentient--than an Earth human, or any of the aliens who collaborated on their creation. The "blood" is what conveys the energy from the amulet through the bodies. So a DH can "bleed" to death. Or into stasis that's like death.

As of our last discussion, I believe, we'd decided that the DH are bodies except for the trimmings--epaulets, helmet, belt, claw-cable--which are add-ons. What Portal was wearing was a hollowed out DH body, as well as some of the add-ons. (Maybe we should go back to the other idea that everything we see is a sheathe that fits over whatever the body really looks like. Makes Portal seem less psycho and sadistic, which I'd like.)

AND, OF COURSE, WHAT'S UNDER DARKHAWK'S HELMET?

I still maintain that this is the bodies's most potent weapon. For, when you look at the face under the helmet--you see the thing in life that most scares you, embodied in a face. The effect is so powerful, it even works on the wielder. So, when Chris looks into the mirror, he sees himself as he would look if he were old and disease-ridden. Another person looking at it might see a figure from a childhood nightmare, etc. An objective recording of the face--a photo or an imprint made with ink or in clay--would just show it to be a blank, featureless thing, like the Chameleon's face, which is modeled on a blank artist's mannequin.

This hypnootic effect is the DH's ultimate protective device. It makes sure that most sentient enemies stay away. For there are very few that can face their worst horror. Only the fearless--or the insane--could stand up to it. Besides, it will be a while--if ever--before Chris figures out that everybody who looks under the mask sees something different. And even longer--if ever--before he figures out that the face can be used offensively. Evidently--as seen in the scenes where DH removes his helmet and then covers his face with scarves--the face must be fully exposed for the effect to work.

Finally, "Darkhawk" is the phonic equivalent (in the language of the alien inhabiting St. Johnny's mind) for the alien term for the DH body; it means "consciousness-droid" in that language. Hence, St. J's calling DH "Darkhawk."

**BACKSTORY:**

Not so long ago.

In a galaxy very far away...

Meet DARGIN BOKK, intergalactic gangster, native of the planet LUQ. Whatever you want, no matter its legality or morality, he can get it for you. And you'll like his price. No matter what. It is while returning from a mission getting some illegal product for a client--and walking away with a tidy, but hardly spectacular sum--that inspiration strikes Bokk, an inspiration that will enable him to realize his fondest dreams of wealth and power.

His idea? He will create the ultimate expendable agents--to use as anything-- soldiers, smugglers, enforcers, explorers-- and sell them to the highest bidders. He knows that on various planets in his galaxy, there have been important scientific discoveries that, individually, are major breakthroughs. Bokk's inspiration is to steal the technologies's creators and force them to work together--through blackmail, bribes, physical threats, whatever will work--to synthesize a creation that will use ALL the findings--and will make him the richest man in the galaxy.

*Below, right:* Mike's pencil roughs for page 19 of *Darkhawk* #25, drawn from Danny's plot. *Below left:* Mike's tight pencils, with Danny's captions lettered in by Bill Oakley. (See how it finally came out on the next page.) [© 2006 Marvel Characters, Inc.]

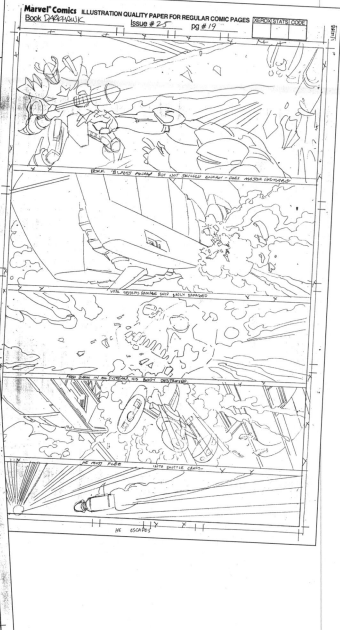

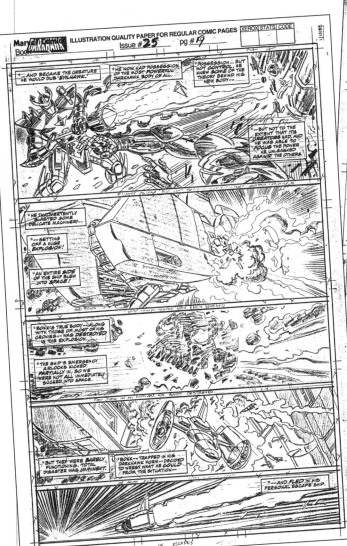

From fragments of ideas and conversations between members of a creative team, to a document that codifies it, to a finished story that delivers those concepts to the world, a story can travel a complicated route on its way to being told. Hopefully, the results are worth all the effort.

...Ultimately, even those who came onto the project willingly grow to hate and resent Bokk, but it is too late. He has a hold over all of them. They will help him--or pay the ultimate price.

Or will they?

For, even as these scientists from different worlds put their knowledge together to create what we will ultimately know as the five Darkhawk prototypes, they plan and plot among themselves. They fear for their lives, some more than others, but they ultimately realize that Bokk does not mean to let any of them live after they have served their purpose.

At last, the day comes when they will rise up against Bokk and his allies. They plan to make use of the still experimental DH bodies and overthrow him, even at risk of losing their lives. (Of course, when we finally--maybe issue #50--give the full backstory to the readers, we will show these guys to be more diverse, not of one mind or opinion, and some of them even take Bokk's side. But for the sake of brevity, let's just say here that they all rebel.) They make their move, enter the bodies, and attack!

But Bokk and his loyalists are formidable. A great battle occurs in the ship in Null Space. Bokk, himself, gains control of the most powerful of the DH bodies, but-- unable to fully control all this power--he causes a great explosion that rocks the ship! A whole side of it is blown out! Bokk's "human" body is destroyed--he is trapped with his DH body--and he escapes in an escape craft (the ship we saw in issue #20). He is in Null Space, though, without a clue as how to get back to his home galaxy.

The same explosion--or series of explosions--sends the consciousnesses of (at least) two of the scientists zapping out of their bodies. They rocket through dimensional barriers--

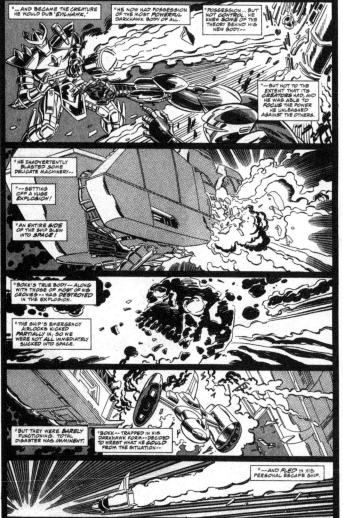

The Darkhawk bodies, created by Bokk, from *Darkhawk* #25. Written by Fingeroth, art by Manley and Aaron McClellan. [©2006 Marvel Characters, Inc.]

THE END

# Getting Published
## by Danny Fingeroth

You've read a thousand books on creating comics (and probably on creating novels, movies and TV shows). You've taken classes. You read *Write Now!* and *Draw!* religiously. So…what next? How do you get your work out into the world?

Whether you want to create super-human adventures, personal stories, or historical accounts, you no doubt have the aim of having your work seen and read by more than your family, friends, co-workers and/or schoolmates. But how do you do that? If you're the greatest writer and/or artist of all time—how do you let people know? After all, money aside, most storytellers want to share their plots and characters and ideas with other humans. Storytellers are communicators.

Well, there's lots of ways to get your work out there, now more than ever. As we discuss elsewhere in this book, there's the self-publishing route, either in print or, increasingly, online. But if you want to get a publisher of comics and graphic novels to publish your work, or to hire you to work on their properties, how do you do it? How do

Of course, most publishers have submission guidelines on their websites. And it's not impossible your work will be seen if you go that route. But what can you do to make yourself and your work stand out—especially if you're a writer? After all, an artist's work can be evaluated pretty quickly—but it's hard to get a sense of a writer's skills at a glance, and most editors just don't have the time to look at writing samples.

So, here are some ways that people have used to get their work seen. None are foolproof. None are guaranteed. None are a directive to do it exactly the way some established creator has done it. It goes without saying everyone has a unique story of how they broke in. You have to learn from others' stories the best way for you. All should prompt you to think of some way that you might put your spin on ways others have gotten (or made, if you prefer) their "breaks."

- Try to get a job as an unpaid intern or paid assistant at a publishing company. You'll learn the business and meet people.

Logos are TM & ©2006 the respective companies.

you separate your work—and yourself—from the thousands of other people who would also like to do this for a living.

It ain't easy. But it isn't impossible, either.

What you have to do is get your work in front of someone who makes decisions for that publisher about what to print and whom to employ. And you have to do it such a way that demonstrates you're talented, dependable, enthusiastic, and not insane.

- Try to become a creator's assistant. You'll learn a lot.

- Show your stuff to editors at conventions. Hint: It's easier to make contact with someone at smaller, local conventions than at huge shows like San Diego or Chicago.

- Publish something yourself and use it as a calling card. Brian Bendis did this for ten years, until he had amassed a solid, respected body of work. Then Marvel came knocking at his door.

- Present any finished storytelling work you've done that you think is good, even if it's not in comics. Did you do an indy film that you can send a copy of? Did you write a novel that there's been some interest in? Hey—that means you finished something you started! It helps if you're a "name" in that other medium, of course—-but it's not necessary.

- Work for a smaller company for little or no upfront money. It will give you published material to show and demonstrate that someone was willing to take a risk on you first!

- If you get invited to submit ideas, submit something an editor can say "yes" to. Don't submit super-hero ideas or art to an indy publisher. Don't submit a story about breaking up with your girlfriend to a super-hero company. If you're an artist, show you can do panel-to-panel storytelling, not just cool pin-ups. If you're a writer, start with short ideas for work-for-hire stories or short, intriguing teasers for your own material. Be prepared with more detail or more ideas if requested.

- Bottom line: put yourself in the shoes of the person and company you're trying to get interested in you, your ideas, and your work. If someone you never heard up walked into your office or sent you an e-mail, what would it take to get you interested in their work when you had a thousand other things to do?

# Self-Publishing
## by Danny Fingeroth

Larry Young's *True Facts: Comics' Righteous Anger: A Pocket Guide to Self-Publishing Your Own Comic Books.* [©2006 AiT/PlanetLar.]

There are any number of ways to publish your own comics. In the resource section elsewhere in this book, there are links to sites that talk about the various options. The Comics Reporter Site, as well as the StickMan Graphics site both give you lots of information about formatting your comic for printing, as well as where to find printers who will do small print runs for reasonable rates. And AiT/PlanetLar's Larry Young's book, *True Facts,* gives this successful self- (and other) publisher's take on the rewards and pitfalls of doing-it-yourself.

Depending on your aim, self-publishing can be pretty simple to do. You can run copies off and staple them together. You can get a little fancier by printing your comics at a Kinko's type place, and so on. Again, decide what your aim is. Just want to share a laugh with your pals or have something cool to give away at an indy comics show, then low tech may not hurt, and may even give your work a "homemade" look. Want to get someone to publish your stories or looking to impress a Hollywood producer type? Then maybe you need to spend the time and money to produce a slicker package. Maybe your "publishing" needs can be served by just putting your work online.

If your publishing needs and desires (and budget) call for having your comic printed by a professional printer, then TwoMorrows publisher **John Morrow** has the facts you need to know on the next few pages...

# GETTING It OUT THERE:

## Pre-Press, Printing, and Distribution

### by John Morrow, publisher

If you've read both parts of the *Write Now!/DRAW!* crossover up to here, Mike and Danny have you prepared to create the world's greatest comic book. But once the India ink is dry, and you've shut down Photoshop, how do you actually get that puppy out there for people to see (and hopefully buy)? Many people decide it makes sense to self-publish.

I've spent more than the last two decades getting things printed: Brochures, Annual Reports, letterhead designs, and since 1994, books and magazines about comics. My task here is to try to condense that experience down to three or four pages, and give you a primer on dealing with printers and distributors. While I can't possibly tell you everything you'll need to know that briefly, I'm going to cram as much in this small space as possible. So hold on tight; we're going to do this fast and furious!

## The Digital Rules

In no particular order, here's some important things to remember when preparing your comics on a computer:

• *Computers:* Macs (Macintosh computers) are best. Period. Don't bother arguing it with me. You *can* do your work on a PC-based system; just be prepared for possible snags. The printing industry is geared toward the Macintosh, and most of the bugs have been worked out of their systems. Whatever platform you use, check with your printer to make sure they're compatible with it, and you're sending them the right format for your files.

• *Software:* Use name-brand software like Photoshop, Quark Xpress, InDesign, Illustrator, Freehand, and Acrobat. They're the standard for the industry, and are less likely to have compatibility problems (thereby making it more likely that your Labor of Love will end up looking the way you wanted it to). Use the latest version that's been in wide release for a while, but check with your

printer before you try to send files created in a version that's recently been updated; printers spend years getting the bugs worked out of current software, and don't always immediately upgrade to potentially buggy new versions as soon as they're released.

• *Sending files:* Check with your printer on how they like stuff shipped. Some take smaller files by e-mail or sent to an FTP site (don't forget to "Stuffit" or "Zip" your files before sending, which not only makes the files smaller for quicker sending, but makes it more likely they'll be readable on the other end). Others like files on disk, sent via Federal Express or other overnight courier. And when sending files on disk, check with your printer on what

disks they accept: CD, DVD, Zip, etc. If you're using an ten-year-old Syquest drive, don't automatically assume your printer still supports such outdated technology. Computer technology is constantly changing; keep up with the times.

• *File formats:* Use TIF, not JPEG or EPS, for scanned or drawn artwork files. JPEG files are smaller for a reason; they "average" similar groups of pixels into one big blob of color, resulting in loss of quality (although it only starts getting noticeable if you use a lower JPEG setting). TIF doesn't degrade your image, even if you use its LZW Compression (a great way to make TIF files smaller if size is a concern). Only use EPS for "vector" art (like logos and type, where the art is actually "drawn" on-screen with a pen tool, or includes a font). Don't send BMP (a PC-format), GIF (a format used for Internet web pages), or anything else. Just TIF and EPS. They're all you need.

- *Fonts:* Use only Postscript fonts whenever possible. (Many printers still have trouble dealing with Truetype fonts, especially when they're mixed with Postscript fonts in the same document.) Be sure to include ALL the fonts used in your documents (and in the case of Postscript fonts, send both the screen and printer fonts). Missing fonts are the #1 reason jobs get delayed at the printing stage.

- *Color images:* You MUST convert them all to CMYK before sending them! If you send them as RGB (the format scanners scan in), you'll be charged extra for the printer to convert them, and you'll be responsible for any images that print wrong because of it. Also, if you use "spot" (i.e. PMS) colors in your layout software, be sure to convert them to CMYK as well (and don't forget to also convert any spot colors in EPS files you've created in Illustrator or Freehand). Also, calibrate your computer monitor, and invest in a CMYK sample book (that shows examples of hundreds of combinations of Cyan, Magenta, Yellow, and Black inks), so you can be sure the combinations you choose in Photoshop will print the color you want them to. Lastly, be sure to convert any RGB "spot" colors you created in Quark Xpress or other page layout software to CMYK, or you'll have the same problems you have with RGB scans that aren't converted.

- *Layout:* Don't send loose Photoshop images to the printer, expecting them to magically put them in the right order for your finished comic book pages. Import them into a page layout program like Quark Xpress, and position them in the right order. Then, do a "Collect For Output" command to assemble all the book's images into one folder, and send that folder to the printer. Be sure to include all the fonts needed to print it. And do NOT try to send press-ready PDF files; unless you've got a lot of printing experience, you'll probably set them up incorrectly, and it's difficult to make last-minute corrections on a PDF file if needed.

- *Trapping:* Trapping is making lighter colors "seep" slightly under darker colors, so you don't get white spaces between colors when they print (colors can shift a little in printing, allowing this to happen). Do it yourself, or ask your printer if they do it automatically.

- *Resolution:* For best results, you need color and grayscale images (i.e. pencil art, colored comics pages, or painted art) to have a resolution of at least 300dpi at the printed size, and line art (i.e. solid black inked art, where no color or gray runs against it) to have a resolution of at least 600dpi. Don't send lower-resolution files, expecting them to magically print well. In most cases, they won't; edges will be jagged, and you'll see "blotches" (called artifacts) in the color areas. Keep in mind that resolution and image size are dependent on each other. If you use a 300dpi image, but print it at 200% of its normal size, you have effectively cut the resolution in half by doubling its size (i.e. at 200% of size, it's now at 150dpi; double the size = half the

resolution). Likewise, if you print that image at 50% of its normal size, you've doubled its resolution (i.e. that same 300dpi image, at 50% of size, is now at 600dpi; half the size = double the resolution). And DON'T try to resize an image in Photoshop to increase its resolution; while it may look okay on screen, you'll just introduce blurry edges and blotchy artifacts. It's much better to rescan it from the original at the higher resolution if possible.

- *Bleeds and gutters:* Leave a 1/8" bleed area (meaning extra area that the printer can trim off without adversely affecting your artwork) on all pages. This allows for variations when your comic is folded, bound, and trimmed. Also, keep important parts of your art at least 1/4" (or more) inside where you want the printer to trim the pages. This is called the "gutter," and doing so will ensure nothing gets cut off or obscured by variations in printing.

- *Proofs:* Some printers offer to send on-screen PDF proofs to save time and money. That's fine for black-&-white work, since it's the printer's responsibility to match the proof they send you. But pay extra for digital hardcopy proofs of any critical color work you're printing. Since every computer monitor is different, it's the only way to insure you'll be getting something that matches what you're expecting. And whatever kind of proof you get, be sure to look over it thoroughly, for mistakes that snuck in when they printed it, proper page order, etc. Once you've okay'd the proof, any errors that you didn't catch are your fault, not the printer's. (And be sure to carefully proof your project in-house, BEFORE you send it to the printer, to catch the inevitable typos that *you'll* have to pay to fix once the printer generates *their* proof.)

# Quebecor World

## Quebecor & Lebonfon Printing Are Here!

We've been dealing with Quebecor Printing of Montreal, Canada for years on our TwoMorrows publications. They're the second-largest printer in the world, and the #1 printer of comic books (DC, Marvel, Dark Horse, Image, and others are printed there). They handle larger print runs (up to 100,000 and more), but for our smaller runs (under 10,000),

we're now using Lebonfon Printing (a spin-off of Quebecor; in a downsizing move, Quebecor sold their smaller plant to the staff that's always run it, so we're dealing with the same people, just under a different name). The main reason we use them is that they're simply the best printer we've found in terms of price, quality, and convenience.

There are other printers out there who can print comic books, magazines, and square-bound books, but we've quoted with dozens of them in the US, and none have been competitive. Lebonfon's advantage is that they specialize in comic books, and have an entire facility set up just for that type of work, resulting in production efficiencies that save you money. They've customized their presses for printing comic books and magazines, including one that can print 32 black-&-white pages at a time. The strength of the US dollar over the Canadian dollar helps too.

Don't hesitate to get quotes from local printers to compare; you might find a good deal locally. But don't forget to factor in freight costs. Lebonfon has another big advantage through their arrangement with Diamond Comic Distributors, where Diamond sends their trucks to Canada every Wednesday to pick up all the comics they've printed that week (and get them in comics shops the next Wednesday). This saves you having to ship books from your local printer to Diamond's various distribution warehouses, including one in England. Also, Lebonfon (for a reasonable fee) will warehouse your extra copies, and as reorders (hopefully) come in from Diamond, you can have Lebonfon put them on Diamond's weekly truck pickup, saving freight costs again.

Here's some tips, based on our experience, and interviews with our rep, Patrick Jodoin.

- *Payment:* If you're a new customer with Lebonfon, expect to pay 100% up-front, *before* your job is

printed. There's a lot of turnover in comics publishing, and they've got to make sure they get paid for their work. Credit terms can be established once you have a track record.

- *Minimum quantities:* While they'll quote you fewer copies, a general guideline is to not print less than 1000 copies of a black-&-white comic. Don't print less than 2000 of a full-color comic. Because of set-up charges, fewer copies will cost you almost as much, and with more copies on hand to sell, you have a better shot at turning a profit. For a ballpark figure, currently it costs about $1100 to print 1000 32-page black-&-white comics (about $1.10 each). 2000 would only cost about $100 more (approximately 60¢ each).

- *Page count:* Because most comics are printed on Web presses (which use large rolls of paper, where 8 or more pages are printed at the same time), keep your page count divisible by 8 (i.e. 16 pages, 24 pages, 32 pages, etc.), not including the cover.

- *Binding:* For comics with smaller page counts, go with "saddle-stitching" (stapling) instead of the more expensive "perfect binding" (square-binding), which is used for comics of 64 pages and higher, and trade paperbacks. They also do "case-binding" for hardcover books.

- *Sizes:* Use standard sizes like 6.625" x 10.1875" (comic book size), 8.5" x 10.875" (magazine size), 5.625" x 8.125" (digest size), 5" x 7.5"

## The Lebonfon Production Process:

1) Call or e-mail this guy (Patrick Jodoin) to discuss your project (don't let the French name or Canadian accent throw you; he, like most of the people at Lebonfon, speak perfect English) at patrickj@lebonfon.com or phone (450)686-8665, ext. 25.

2) Send or e-mail your files, and include a laser printout or PDF file for the production department to go by.

3) Lebonfon faxes or e-mails you a quotation to sign, which serves as the Purchase Order. At this point you'll have to prepay if you haven't established credit.

4) The production department performs pre-press on your files, and generates proofs for you within 3-5 days in most cases. Currently, Lebonfon sends color digital hardcopy proofs or PDF files for color pages, and laser prints for black-&-white pages.

5) You approve the proof, or request changes and specify whether you want to see a corrected proof.

6) You send delivery instructions or a Distribution Sheet (Lebonfon will supply you one to fill out) telling them where to ship copies.

7) Lebonfon generates negatives and makes printing plates, then prints your job. Your negatives are then, at your request, either stored for future use for a nominal fee (good if you think you'll be reprinting the job one day), sent to you (at your expense), or destroyed within 30 days (saving you a storage fee).

8) The bindery department binds your book, which is then packed and shipped per your instructions, or picked up by Diamond the following Wednesday for distribution to stores.

9) If Diamond or another distributor places a reorder, you can fax or e-mail the Purchase Order or a Distribution Form, and Lebonfon will pack and ship it for you (charging a small handling fee).

(manga size), and 4.375" x 7" (novel size). Lebonfon is set up for these sizes, and variations will likely cost you more.

• *Papers:* Generally, using Lebonfon's stock papers will save you money, since they buy these in bulk for their web presses. For black-&-white book interiors, they stock a 50# offset (nice, white, uncoated paper), and two weights of newsprint, 45# and 35# (each a little less white than the offset paper). For color book interiors, you can use these same papers, or for extra sheen and color quality, they stock a 50# or 60# glossy paper. Covers are usually printed on a sheet-fed press (meaning it's done on cut sheets of paper instead of a large roll, and only a few pages at a time), and they stock sheets of 70#, 80#, and 100# gloss papers for covers. (The "#", or "pound" designation tells you how thick or heavy the paper is; the higher the number, the thicker it is.) For trade paperback book covers, they also stock much heavier 8 pt., 10 pt., and 12 pt. papers (with a matte or glossy finish on either one side or both). Other papers are available for special needs, but will generally cost you more.

• *Finishing:* You can, for an additional fee, have them coat your printed gloss pages and covers with a clear matte or gloss varnish to keep them from smearing. They also offer UV coatings and lamination for covers. You can even get embossing, foil stamping, die-cutting, or nearly anything you can think of, if you're willing to pay for it.

• *Turnaround:* Saddle-stitched (stapled) black-&-white comics usually take 2-3 weeks from the time they receive your files. Perfect bound (square bound) black-&-white comics take 3 weeks. Color comics and trade paperbacks take 3 weeks, and hardcover books take 4-5 weeks.

The biggest mistakes people make are:
1) Not checking their proofs closely.
2) Forgetting to include all the fonts/images.
3) Not converting RGB or Pantone colors/images to CMYK.
4) Sending files with a resolution that's too low.
5) Setting up their files at the wrong size.

## The Distribution Maze
The only really effective way to get your comic seen by the public is to go through a distributor, who takes a hefty cut of the sales price (generally 60%) in return for getting it into comic book shops. The top comic book distributor is the aforementioned Diamond Comic Distributors, and your goal is to get your comic listed in their *Previews* catalog (which monthly lists all the comics, magazines, toys, etc. that will be in comic book stores two months later). Other smaller distributors exist—Cold Cut being the main one. But Diamond's at the top of the heap, and without them, you're facing an uphill battle trying to sell books yourself by mail.

All items that Diamond lists in *Previews* are expected to create at least $1250 in sales after Diamond factors in their discount. If Diamond doesn't believe that an item will hit that benchmark, they probably won't list it in *Previews*. And if you're soliciting a new comic, you must provide Diamond with at least a photocopy preview of it first. They won't offer items in *Previews* sight-unseen for new customers.

If Diamond agrees to carry it, you need to send solicitation text for *Previews*, describing your product. It's normally limited to 50 words per item, and they may edit it further due to space considerations, so keep your verbiage concise! Artwork should be sent with the text at 300dpi, 2" x 3" in JPEG format (yes, they actually prefer JPEGs), either by e-mail or on disk.

Remember that it's a waiting game. You send your solicitation to *Previews* four months before it'll be on sale in stores. *Previews* appears two months before the on-sale date, and you'll get a Purchase Order from Diamond (showing how many copies they're ordering) one month before the on-sale date, leaving you just enough time to get it printed.

For more information, call Mark Herr at Diamond at 410-560-7100, ext. 220, or e-mail *hmark@diamondcomics.com.*

## The Bottom Line
No one can stay in business if their product can't turn a profit. I've had to pass on many intriguing publishing projects, simply because the numbers didn't add up. So when you're deciding whether to self-publish, do the math. Make a realistic guess of how·many copies of your comic you think you could sell. Multiply that times the cover price you think the market can bear, and subtract 60% (the distributor's discount). Then subtract the printer's quote for printing the book, deduct any additional expenses (ads you'll be paying for, freight, postage, etc.), and see if the final number is something you can live with. If not, you've got to either raise your cover price (which could hurt sales), find a cheaper printer, lower the page count, or forget the whole thing!

If the total left is a feasible amount for you to make for your time and effort, pray that you guessed the right number of sales, and get it out there! And don't forget to factor in the incredible feeling you'll get the day your finished comic arrives from the printer. No dollar amount can be put on it. Good luck!

**–John Morrow**

# Appendix 1

## WRITE Now! Comics School

It's all well and good to see the way Danny and Mike came up with Thief of Time and her premiere story. You can figure out a lot about how any story is written from seeing the various steps along the way and reading the notes and conversations Danny and Mike exchanged.

But there's also something to be said for having techniques spelled out and demonstrated for you. Elsewhere in this book, Mike shows the way he pencils, inks, colors and letters. In this section, Danny shares insights into and instructions on the story-making process from the writer's point of view. The lessons that follow aren't by any mean everything you need to know—there are countless books and courses on writing—but they're a lot of the basics you need to know in order to bring some critical thinking to your own, or someone else's, writing.

# Ideas and Inspiration
## by Danny Fingeroth

At some point, every writer gets asked: "Where do you get your ideas from?" We all have ideas all the time. The trick is to pick the ones that will make good stories and then write those stories.

- Ideas for story and character come from everywhere. Some places include:

- Newspapers.

- Topical issues—but what's the permanent KERNEL in the topical event that a character can be built on?

- What's "hot" in pop culture—but try to see what's going to be hot OVER THE HORIZON.

- What interesting hobbies, interest, worlds are you familiar with that might make a cool setting or character?

- Conversations you hear all around you.

- Your own life, made into metaphor.

- Public domain material (for example, The Bible and Shakespeare).

Now, there's that cousin of ideas, "inspiration"? Where do you get that from? Again, it's one of those things that strikes us all now and again, and we never really know exactly when or how it will come.

But while you may not be able to control ideas or inspiration, you CAN create a climate and a state of mind where they will be more likely to show up.

Shakespeare gets an idea, courtesy of this detail from Mark Bagley's classic cover to *Write Now!* #1. [Art ©2006 Mark Bagley.]

- If you sit at your computer or writing pad and write for a certain amount of time each day, then when inspiration arrives, you'll be ready for it.

- If you travel and try to experience new things and meet new people, you're building experiences that will become the fuel of inspiration and ideas.

- If you read widely and experience all kinds of movies and TV and theater, then guess what you're feeding your inner "inspiration machine."

- If you carry a pad or recording device of some kind with you all the time and jot down ideas and inspirations as they come to you, you won't feel like an idiot for forgetting some great thought that came to you on the bus.

The point is, we all get all sorts of input from people and things and media all the time. What makes a writer a writer is processing this information and converting it into something new and personal.

The simplest way to become an input-processing machine is to sit at the desk and do it. Write when you're not inspired. Treat it like a job. Because, especially if you're looking to make a living as a writer, it IS a job.

A word of caution—and freedom—especially for relative beginners:

Don't worry about whether or not what you're writing is the most original or wonderful thing ever done. Look how many non-original and non-wonderful things get produced and published. Not that you should ever not strive to do your best work, but in many ways, finishing something is the most important thing. And you can't stop at one. Whether your work is accepted or rejected, you have to keep producing completed works. Especially at the beginning, the work you do will probably be imitating someone else's style or even plots. That's fine. That's how you develop your own voice. (Of course, don't ever try to pass someone else's work off as your own. That's plagiarism.) Journey through the stages of imitating those writers you admire and you'll arrive at your own voice without even realizing it. But don't keep yourself from starting or finishing a piece of writing because you think you're not being original or clever enough. Get a first draft of whatever it is done. Then you can go back and revise it. But don't revise it forever. Eventually, you have to consider something finished and move on to the next thing.

**THE END**

# Pitching 1:

## Springboards vs. Promo Copy
### by Danny Fingeroth

When you submit a story idea (also known as a "springboard") to an editor or publisher, there's a big difference between that and what you submit as ad or promotional copy.

This may not seem significant, but imagine that you're a decision maker at a comics company (or, really, any entertainment company) as you read this paragraph of promo copy for a hypothetical issue of **Fantastic Four** as it might appear in the **Diamond Previews** catalogue:

*In this issue, you'll never guess who comes back to rock Ben Grimm's world! Hint: it's one of the FF's oldest enemies! And wait'll you see what happens to Johnny! It's so daring, so strange you won't believe that we let it happen! And the FF will never be the same again!*

Would that make you want to buy the imagined comic? As a consumer of super-hero comics and possibly a fan of the Fantastic Four, it's likely your interest will at least be piqued by the description of the issue. The purpose of such copy is also (one could say primarily) to entice a *retailer* to order a given comic. If you were a retailer, would the above be enough to make you order heavily on the issue?

Now put on your comics editor hat and imagine that a writer presented you with the summary above as a springboard. You'd probably be, at best, annoyed. Why?

Because what you're trying to sell an editor and what you're trying to sell a reader are two different things.

A reader wants to be entertained. Every promotional item for a piece of entertainment promises a lot—usually more than it delivers. We all know this. But it's a game we are happy to play: Promise me the greatest thing I've ever seen. I'll be satisfied if I'm at least well-entertained for a while. I'll be thrilled if I learn something about human nature and even more pleased if I have a life-changing experience—but I'm not demanding it or counting on it.

But an editor wants more than a consumer. Because, before the work in question gets to the consumer, an editor must know for certain that it will at least attempt to be solid entertainment, and possibly become even more. So, to get an editor's interest, here's how the same Fantastic Four story might go as a springboard:

*The Thing accidentally frees the Super-Skrull from captivity in*

*Reed's lab! The Skrull overpowers Ben and, one-by-one defeats the rest of the FF. It's only when the Skrull attempts to kill the Human Torch that Reed is able to trick him into increasing the Torch's powers so beyond control that the Skrull is defeated. Now all the team has to do is keep Johnny's out-of-control flame from destroying the city, which they are able to do when they convince the Skrull that he's in as much danger as they are and he helps them save the day.*

Both types of copy should be written to create excitement. But the editor needs to know exactly what you plan to do in your story that will make it so exciting. In a springboard, you GIVE AWAY THE SECRETS—sometimes in the first sentence— that you only want to hint at in promo copy. You don't want the editor to buy the comic— you want him to buy your *story* (and *you* as a writer)! The difference between promo copy and springboard-pitch copy holds true for work you own and control as much as for work you want to try to get on other people's properties.

THE END

# Pitching 2:
## Format and Function
### by Danny Fingeroth

Like everyone else, comics editors are overworked and underappreciated. So how do you convince them to make time to look at your submissions and pitches?

First you have to figure out who your idea is appropriate for. Marvel? DC? Dark Horse? Fantagraphics? Are you going to publish it yourself? (Even if that's the case, you'll probably have to convince investors to take a chance on you.) Once you've figured out who to show your idea to (and have done what your lawyer has advised you to do to protect the idea), then you have to find out the company's submissions guidelines. Many publishers have them on their websites. Follow them. But (and you didn't hear it from me), that's a pretty tough way to get noticed. After all, everybody with an Internet connection and an idea is submitting like that.

A different type of pitching is seen on the cover to Will Eisner's 1949 **Baseball Comics.** [© 2004 Denis Kitchen Publishing LLC.]

Your job is to develop a good relationship with someone who works at the company you're pitching to. It can be an assistant you speak to on the phone and develop a rapport with, an editor you briefly met at a store signing, a friend of a friend of a cousin who knows somebody at a company that does business with the publisher—anybody who might be able to push your idea to a next level. (Stalking does not count as a good relationship. And buying drinks for editors at conventions does not make them your friends. Think of this as what it is—job hunting.)

Okay, now you have a relationship. How do you make the most of it?

Imagine you're that overworked editor eating lunch at your desk and want something to read. You spot that bright green envelope from that writer you met at a small local convention who was funny and enthusiastic and told you how much she wanted to write comics, who didn't linger, but just asked if it'd be okay if she sent you some ideas.

So you open the green envelope that stands out (but doesn't look like it's from an insane person). And in the envelope is:

* A short cover letter that reminds you when and how you met the writer.

* A copy of a self-published comic the writer did with an artist-friend.

* Three story ideas ("springboards"). Each idea is brief and to the point, taking no more than half a page, and tells you what the story is about, who the protagonist and antagonist are, what the inner and outer conflicts are, and why buying this story will make you seem like the greatest editor who ever lived.

Giving the editor three springboards gives him a selection of easy-to-digest ideas. If he likes one, your next steps will be what the editor says they are, which could include providing:

* A longer version of the story. (A one- to two-page outline).

* Profiles of the story's main characters, especially if they're not ones everybody knows.

* An overview, if appropriate, of your long-term plans for the characters.

* Your opinion of what niche you and/or your story fills.

* Who the expected audience for the story is.

These questions may be asked (and answered) in person at a meeting, on the phone, or via e-mail or letter—however the editor wants to pursue it.

Often, the editor will like part of your idea but want changes or alterations made to story or character. It's up to you how much to compromise, but being resistant to suggestions may make you someone the editor won't want to work with. Or you may find yourself in a situation where the editor will reject your ideas but like your writing enough to request more ideas, or even that you take an idea of his and expand it into a story. Again, it's up to you whether or not to take the offer, but refusing it may shut doors for you.

Of course, not every pitch or writer is met with open arms. If your ideas are rejected or ignored, see if the editor is interested in seeing revisions. If not, try to figure out why the pitch wasn't accepted, make what modifications you think will improve it, and pitch it to another editor or company. And don't forget to keep coming up with new ideas. While you should have faith in an idea you really believe in, don't become so focused on it you neglect trying other things, as well.

**THE END**

# WRITE Now! Comics School
## MINI-LESSON

# Character Development

## by Danny Fingeroth

Who are your characters? Why should anybody care about them?

These are the challenges you face when writing a story.

Creating a character can seem deceptively simple. Pick a hair color, a body type, maybe a nifty superpower, a romantic interest, and a car-style, and you have a character, right? Well, a very shallow character. One who people have no real reason to care about. You need to give your character **CHARACTER**. You can call this personality, if you like.

As with the other elements of story-making, character can work on several levels. A hero who claims to be dedicated to pursuing justice can have a certain interest for your readers, especially when pitted against a villain who champions evil.

But what if your hero has a bad temper and accidentally kills an adversary who was shoplifting a pack of gum? What if your villain

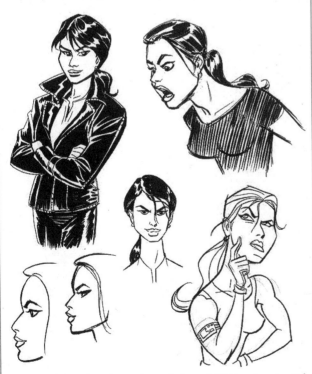

Some Mike Manley sketches, as he worked on establishing character and attitude for the character. [©2006 Danny Fingeroth & Mike Manley]

gives all the proceeds from his crimes to cancer research? Wouldn't that make them more interesting? Wouldn't that make them more like people you meet in daily life—flawed humans whose actions are often at odds with their stated intentions, or whose actions are a mixed bag of good and bad?

That's what characterization is about. And that's the difference between surface characterization and deep characterization.

*Surface characterization* is when a character seems to be about what they say they're about. In a Superman story intended for younger readers, Superman is about doing the right thing, and doggone it, he always does the right thing.

*Deep characterization* is what it sounds like. A character has more complex motives. Superman, in a story for an older audience, may sometimes question why he does what he does. "Is it worth it to do the right thing when people keep committing crimes no matter how often I do the right thing? Maybe I should retire to a desert island." The struggle to keep doing the right thing even when it's not appreciated or when it's hard to know what the right thing *is*, is a story that involves deeper characterization.

Another way of looking at deep characterization is as the real motivations a character has. This is often the opposite of, or contradicts, what a character says are his or her motivations. Face it, in real life, we don't even know our own motivations much of the time.

How complex do you want your characters to be? If a hero is too complex, do they run the danger of being unlikable? Spider-Man is just flawed enough for people to relate to him and feel good about it. A reader feeling: "He screwed up in that situation just like I would have," is one of the keys to Spidey's longtime success. If Spider-Man intentionally treated his loved ones badly, he'd be more complex, but we wouldn't like him as much, would we?

Generally, your *main characters* should have the most complex characterizations.

*Supporting characters* are just that. They exist to reflect qualities of the protagonist(s). Commissioner Gordon may now and then have a story focused on him, but generally, he's there to tell us more about Batman's relationship with society.

*Incidental characters* need the least depth of all. They exist solely to move the story along. The guy who runs the newsstand exists only to sell the newspaper to the hero. "Mid-50s, gruff, needs a shave," may be all the characterization he needs.

THE END

# Story Structure
## by Danny Fingeroth

Ever notice how two people can be recounting the same event, and yet one of them makes it seem exciting and the other dull as dishwater? A big part of the reason for that is structure. The person who tells the compelling version knows when and how to introduce elements of the story.

Every story needs structure. Maybe avant-garde, minimalist writing doesn't, but that is writing with a purpose other than that of most fictional story-telling. Most stories, certainly most genre stories, are intended to entertain or to educate, sometimes both. Over time, we have learned that the most effective ways to do this are with structures that humans respond to. People seem to like to be led down familiar paths of story. They like to be surprised, too. Knowing how to balance familiarity with surprise is a big part of the writer's job. Knowledge of structure is an important tool to balance the familiar and the surprising.

Here are some "rules" of story structure, and specifically how they apply to comics. They will serve you well when you're trying to see why a story might not be working. (Rules, of course, are made to be broken. Structures are made to be messed with. But it's good to know the rules before you start fooling around with them.)

Most stories we see hew to the classic "three-act structure." Another way of saying this is "beginning, middle, end." Nursery rhymes are stories. (See below.) Jokes are stories. "A guy walks into a bar…" You want to know what happens next.

Here's story guru Dennis O'Neil's Basic Structure for a 22-page super-hero comic book story:

- Hook (A visual or story point that makes you have to keep reading)

Dennis O'Neil's *The DC Comics Guide to Writing Comics*.
[©2006 DC Comics.]

Robert McKee's *Story: Substance, Structure, Style, and the Principles of Screenwriting*.
[©1997 Robert McKee.]

- Inciting incident. (The event that really gets the story going.)

- Establish situation and conflict. (Major visual action.)

- Develop and complicate situation. (Major visual action.)

- Events leading to —

- Climax. (Major visual action.)

*Note: Since comics are visual, major events and turning points are usually visual. But story point can be made in dialogue or with subtle visual incident if the story is strong enough and the tellers highly skilled.*

Here's a useful mnemonic device Jim Shooter used to use to map the basic structure of a story. It's simplistic, of course, but also instructive:

- Little Miss Muffett (Introduce character)

- …sat on a tuffet, eating her curds and whey (introduce the status quo)

- …along came a spider (establish the antagonist and conflict)

- …and sat down beside her (build suspense)

- …and frightened Miss Muffett (rising conflict)

- …away. (resolution of the conflict and story denouement all at once)

That's a little bit of info about story structure. There are shelves full of books on the topic, and all have something to offer. See if you can find the elements of structure in the story Mike and I are presenting here in the crossover. Where do we follow "the rules"? Where do we break them?

**THE END**

# Conflict
## by Danny Fingeroth

One definition of a story is: *somebody wants something, and someone or something else keeps him or her from getting it.*

That "someone or something" is the **conflict**.

If a story was about a day where nothing went wrong and nothing was at stake, it wouldn't be much of a story. The thing that makes a story about something is the conflict.

Conflict can be:

- Physical. For instance, two characters battling. Under this could be included emotional arguments or intricate psychological conflict between two people. Also, outside—hurricanes, bombings, etc.—would be forms of physical conflict.

- Internal. This involves a character at odds with him or herself. For instance, an alcoholic desperate for a drink, but knowing if he takes one he will be lost, must choose between need and desire.

- Personal. Has aspects of the first two types. For instance, one partner in a romantic relationship may want to get married, the other may not.

Let's say we have a situation where Spider-Man is about to go out to fight Doctor Octopus, who's trying to kill Jonah Jameson. As Spidey's heading to the rescue, he hears that Mary Jane is trapped in an elevator with a madman who threatens to unleash a deadly virus on the city. What does our hero do? Save a guy he hates (Jonah) or the woman he loves—and the city, as well? That's what's called personal conflict. The protagonist (the hero) must choose between two things that are seemingly impossible to choose between. These echo our most difficult choices as humans, It's easy to choose between something good and something bad. Choosing between two goods or between two bads is when life gets hard—and drama gets exciting!

Robert McKee, in his book **Story**, phrases it this way: "Choice must not be doubt but dilemma, not between right/wrong or good/evil, but between either positive desires or negative desires of equal weight and value. True Character can only be expressed through choice in dilemma. How the person chooses to act under pressure is who he is—the greater the pressure, the truer and deeper the choice to character."

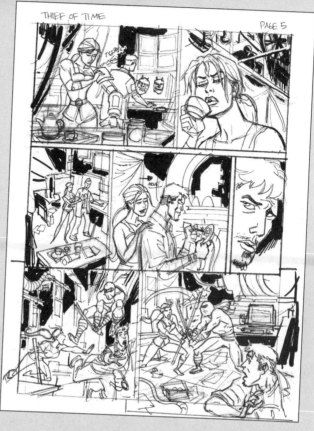

An early pencil rough version of page 5 of "A Glitch In Time." There are at least two types of conflict going on in the page. Can you identify them? [©2006 Danny Fingeroth & Mike Manley]

Another way to say it: *conflict defines character.*

When devising an internal or personal conflict for a character, ask yourself: what's the worst thing (besides dying) that can happen to this person? What decision would give them the most trouble? In super-hero stories, you usually have the added need to externalize that conflict in a physical manner. Stan Lee and Steve Ditko's *Spider-Man: Master Planner* trilogy has one of the more elegant mergings of external, internal and personal conflicts. In it, the thing that Spider-Man needs to save Aunt May is the same thing Doc Ock needs to rule the world.

Try to introduce your story's conflict(s) as early as possible. That way, your reader becomes emotionally involved with your characters from the beginning. And that's a good thing.

THE END

# Scripting Methods

## by Danny Fingeroth

So you've absorbed way too much advice from people and books about writing. You just want to sit down and write your comics story.

How do you do it?

I'm not talking about structure or character or even plot. I mean, how do you indicate to someone else what your ideas and story points are? How do you *literally* write the story?

If you were writing a movie script or a teleplay, there would be established formats you would need to conform to if you wanted to be considered seriously in those industries. But comics has no such standardized formatting. Still, there are, broadly speaking, two ways to write comics scripts.

One is generally called "full-script." This means the writer breaks the story into pages and panels. You describe what goes on in each panel and, at the same time, you write the captions, word balloons and sound effects for each panel. In theory, once you (and, often, an editor) have agreed that a script is accepted, that's the end of your involvement with a story. A piece of a full-script might look like this:

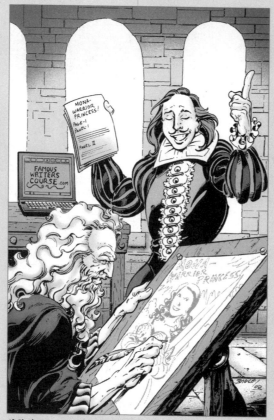

If Shakespeare and DaVinci were comics creators, would they have worked work full-script or Marvel style? Illustration by Mark Bagley and Scott Hanna. [Art ©2006 Mark Bagley]

The other style of scripting is called "plot first" or "Marvel style," so called because it was popularized by Stan Lee and his collaborators on Marvel's early comics. It gives a summary of a story that the artist then breaks down into panels. The dialogue and captions are written *after* the penciling is done. So the scene above might look like this, and be part of a page-description:

**PAGE ONE:**

*Multi-paneled page. Inside the Starship Enterprise. The lights are dim. Kirk lies slumped in his chair, barely conscious. Next to him, Spock holds his hands to his head, receiving a telepathic message from the Romulans. Spock quickly realizes that it's an attempt to take over his mind. We see Spock struggle with the mental assault. Weak as he is, Kirk tries to encourage him, and his words give Spock the ability to resist. By the end of the page, Spock is clear-eyed and in control.*

There are pros and cons to both styles. The full-script can give a writer a certain degree of extra control over the pacing, while the plot-first style enables the writer to make the most of the artist's strengths and contributions, and to make up for anything that may not be drawn exactly as the writer envisioned it. Many writer and artists today work with a modified style somewhere between the two styles, where the writer describes all panels and text, but the artist has the freedom to modify the script, and the writer then sees the story again and adjusts the text as needed.

**PAGE ONE**

PANEL ONE: ART: INTERIOR. COMMAND DECK OF THE STARSHIP ENTERPRISE. THE ONLY FIGURES IN THE ROOM ARE SPOCK AND KIRK. KIRK IS SLUMPED IN HIS CHAIR, NEARLY UNCONSCIOUS. SPOCK STANDS NEXT TO HIM, HANDS TO HIS TEMPLES.

1 KIRK: Spock… stop the Romulans…

2 SPOCK: They're beaming a telepathic message… claim they mean us no harm…

In *Thief of Time*, Mike and I worked plot first, though we went back-and-forth in phone and e-mail conversations to get the story to a place where we were both happy with it.

THE END

# Writing Dialogue

### by Danny Fingeroth

**READER:** But, Danny, dialogue must be the easiest thing. You just write down what you hear the characters saying in your head, right?

**DANNY:** Yes… and no…

**READER:** Well… that's clear. *Not.*

In life, people rarely speak in complete sentences. People rarely say exactly what they mean. People leave it to facial expression and tone of voice to get their point across.

In all narrative writing, the trick is to simulate real speech. Your dialogue has to move the plot along, convey surface and deep characterization, express the characters' (and the writer's) point of view, *and* be entertaining. That's a lot to ask of 26 letters.

In comics, you have an even tougher challenge. You have static art and limited space to get all those things across. Your dialogue must be believable, but not meandering and repetitive. How do you do this?

- Practice dialogue writing. Try different approaches to the same scene. One time let your hero do most of the talking. Another time, let the villain dominate.

- Listen to people talking in the world around you, then adapt how they speak into literary speech. You're after a simulation of real speech.

- Carry a notebook with you and write down cool things that people say. You'll find a place to use them.

- Recite your dialogue out loud. Does it sound convincingly realistic (not real—*realistic*) to you?

- Practice all the above on a regular basis.

When writing dialogue, ask yourself: Does each character have a distinct personality? For example, a college professor might say: "I propose we initiate aggressive action." A longshoreman might say: "Let's trash the bums!" Of course, to go against expectations, and to create distinctive characters, you might have a story where your professor was the one who spoke in tough-guy slang and the longshoreman spoke like someone with a Ph.D. (An aside: Simulations of dialects and accents should be used in a limited fashion, so as not to take the reader out of the flow of the story.)

What's the optimum number of words in a page or a panel? That's pretty flexible. It depends on the aim of your story. Want a longer read with a lot of insights? Then dialogue-heavy scripting is for you. Want to let the visuals carry the story with a minimum of yack? Then you have to keep the dialogue sparse. A good idea, especially when you're starting out, is to do stick figure thumbnail drawings of your story (on 8 1/2" x 11" paper) and letter in all the word balloons and captions. You'd be amazed at how much (or perhaps at how little) room your dialogue takes compared to what you imagined it would.

And did I mention that you need to practice this stuff?

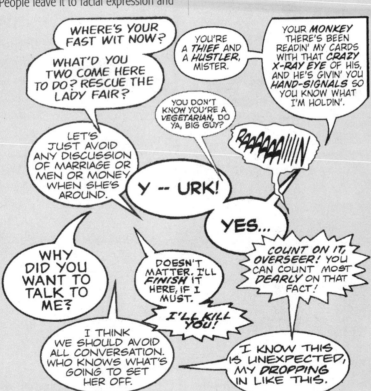

# Theme
## by Danny Fingeroth

You've heard this term a thousand times. Theme. It's also known as "controlling idea" or even as the "moral" or "lesson" of your story.

Whatever you call it, it's what your story is REALLY about.

In other words, your story may seem to be about two musclemen in spandex beating the stuffing out of each other. Or it may seem to be about two people in love who can't be together. Or

One of the great comics (or *anything*) themes was stated for the first time in Stan Lee and Steve Ditko's Spider-Man origin in *Amazing Fantasy* #15. [© 2006 Marvel Characters, Inc.]

it may seem to be about people at high school and the turmoil they go through in their personal lives.

And on a plot level, that is what those stories are about. But every story, consciously or not, has a hidden agenda. The writers are trying to teach you or convince you of something. There's no way to tell a story without a point of view and an opinion. That opinion or idea doesn't have to be novel or unique. Actually, given the consistency of human nature over the millennia, themes are pretty familiar and constant.

For example, here are some themes you may be familiar with from famous stories:

- "A mistake today can destroy the future." [*The Terminator*]
- "Love is better than greed." [*Jerry McGuire*]
- "With great power there must also come great responsibility" [*Spider-Man*].

Theme is one of those things that people will not always agree on a definition of. There are those who say that the theme of a story is "responsibility" or "love" or "success" or "faith." I think these are *subjects*, but not themes. "With great power there must also come great responsibility" is a theme. "Love can make the greatest hardship endurable," is a theme. "Success comes at the price of other things you may value," is a theme. But certainly someone can say that the theme of *Spider-Man* is responsibility and they wouldn't be wrong, in the sense that theme can be defined as a close relative of subject. But I still find the most satisfying definition of theme being the one I stated earlier. I also think that definition is most of use to a writer, since the writer can see if what he or she is writing (or has written) advances and serves the theme they intended.

And that's not to say a writer has to—or even should—start writing with a theme in mind. Very often the writer, especially in the throes of inspiration, will be unaware of a story's theme. And that's appropriate. But when you've finished an outline or a rough draft, then go back and think about what you've written. As you do, you'll discover your theme. At that point you may say "that's a stupid theme—and the opposite of what I believe and/or was intending to convey." At that point, you can focus or change your theme by emphasizing or narrowing certain things in your story. (These changes can be to character, plot, setting, to any and all elements of your story. They all subtly come together to put across your theme.)

Because, like it or not, your story will have a theme, and you may as well be in control of it.

**THE END**

# Subplots and B-Stories

## by Danny Fingeroth

A story doesn't have to have subplots and B-stories. You can tell a perfectly good story straight through from beginning to end, focusing on your main character and what happens to him or her.

In short forms of storytelling—jokes for instance—you don't want or need to know about anything beyond the main story. When the kangaroo walks into the bar, you just need to know that the bartender says "We don't get many kangaroos here," and that the kangaroo replies: "And at 20 dollars a beer, you won't get many more." You don't need to know that one of the customers is planning to rob the place or that the bartender just broke up with his girlfriend.

But many stories are, of course, more complicated than that. And one way they are satisfyingly complicated is with subplots and B—and C, D, E, etc.–stories. These two are sometimes hard to tell apart, but they are quite different in function and in construction. As a general rule of thumb, subplots are secondary stories to the main plot of a story. The main character (protagonist) of a story is the one who drives the main plot. Ditto for the antagonist, be it a person or a thing.

A good **Superman** comics story and a good **Seinfeld** episode have in common the deft use of subplots and interweaving stories. [Superman © 2006 DC Comics. Photo ©2006 American Express.]

Things that happen to other characters than the main ones are subplots. In a Superman story, if Superman is fighting a space monster, Jimmy Olsen investigating how the monster came to Earth is a subplot. If the writer is doing his job, something Jimmy finds out may end up helping Superman defeat the monster. Or a kid may find inspiration in the bravery Superman showed while fighting the monster to go and face a difficult situation at school—a bully who's a figurative "monster," for example. That's a secondary story that wasn't essential to Superman's battle with the space monster, but echoes it thematically, and shows how Superman has an impact on people in many ways he's not even aware of.

Another type of subplot, especially used in comics and other serial forms of storytelling, is one where a storyline is introduced a few panels or a page or two per issue. For instance, a Superman story might have a subplot about a meteor that lands and emits strange fumes in one issue. The next issue, a passerby may be overcome by the fumes. In a third issue, the passerby begins to exhibit strange powers. By the fourth or fifth time we see this subplot progress, the passerby has become Meteor Mogul and challenges Superman from atop the Daily Planet building. At this point, MM has "graduated" to main plot status, but other subplots are in the works, (hopefully) building a constant state of interest in the readers, keeping them coming back issue after issue.

Ideally, subplots should echo the THEME of a story. (Luckily for you, there's a lesson on theme elsewhere in this book.) Essentially, if theme is what a story is REALLY about (on a non-plot level), then subplots should be really about the same thing. When subplots and B-stories come together at the same time as the main story, that's when the most satisfying story-experiences happen, with the notable exception that, in serialized fiction, you often want to have a subplot that continues to the next issue.

There are also story elements called B-stories (as well as C, D and E-stories.) Some people use the term interchangeably with "subplot." But in a case of, say, an ensemble story—one where there is any kind of team involved (this includes police and army stories), then letter-stories are *parallel* stories. What you're really seeing is three or four separate stories, all thematically tied together. Almost always, one of these stories is most important, but all four could have occurred without the others. Presented together, they make a work resonate thematically. As a writer, you need to know this. All a reader or viewer needs to know is "that was cool" or "that was intense."

The **Seinfeld** show was great at having interweaving stories that each had the same importance, but reflected each other and usually intertwined at the end. **NYPD Blue** and **Homicide: Life on the Street** also did parallel stories well. The main cases generally got more screen time and were handled by the stars, who were by definition the main characters, but other thematically-related cases were investigated by other detectives at the same time.

**THE END**

# The Editor's Role
### by Danny Fingeroth

"Who is this editor person, anyway?" you may ask. "Why should my creative vision be subject to anyone's meddling and tinkering?"

Needless to say, things aren't that simple. And what makes it even less simple is the fact that the editor's role is so amorphous. It varies from company to company, person to person, relationship to relationship, comic to comic. Tom DeFalco defines an editor as "a walking opinion." What an editor has to be is someone who can shepherd projects through from beginning to end.

The editor has to look at a submitted piece of work and decide if it is what the company he or she represents wants to publish. Oddly enough, the editor also represents the reader. If the imagined reader in the editor's head isn't interested in something or doesn't understand something, neither will the editor.

Autobiographies of two men who pretty much defined the role of the comics editor. *Excelsior: The Amazing Life of Stan Lee* by Stan Lee and George Mair and *Man of Two Worlds: My Life in Science Fiction and Comics* by Julius Schwartz, with Brian M. Thomsen. [*Amazing Life of Stan Lee* © 2004 by Stan Lee and George Mair. Characters ©2006 Marvel Characters, Inc.] [*Man of Two Worlds* © 2000 by Julius Schwartz and Brian M. Thomsen. Characters © 2006 DC Comics.]

Editors represent the creative people to the business people and the business people to the creative people. They help create the criteria and also receive the criteria of what's acceptable from the powers that be. If a comic is great, the creators get the credit, no matter how much input the editor had. If a comic is terrible, the editor may take more than his or her share of the blame.

*Bottom line: The editor's job is to make sure that something of as high quality as possible appears on the newsstands or in the bookstore when it is promised.*

As a rule of thumb, here are some important things to know about editors:

- In companies where the stories are corporate-controlled (anything dealing with big-name properties like Spider-Man and Superman), the editor will:

  - Assign work.

  - Put together creative teams.

  - Approve, suggest, or even mandate certain story and character points. This may seem "unfair," but the editor is the guardian of the character and has to look out for the interest of the franchise.

  - Accept or reject the work you do. This includes asking for or demanding changes to your work. You can politely argue with the editor's decision, but ultimately, it is just that—the editor's decision.

- In a situation where the material is "creator-owned," things are different. This is where you're hired to write and/or draw stories that are based on your own properties (although you'd better read your contract carefully—ownership's irrelevant if you sign various rights away).

  - Ideally in such a situation, your editor will want to help you make your story the best it can be. The editor here may have more of an advisory role and not be empowered to make you do anything with the story or characters that you don't want to do. This will all depend on what the deal you signed on for is. However, if your work violates certain standards the publisher has, they can probably refuse to publish your work.

And don't forget: always be nice to assistants and interns. They can champion your work when their boss is too busy to notice it. They can make sure your invoices get processed as quickly as possible. And they are the editors of tomorrow. They won't forget who treated them well—and who treated them badly—before they were promoted.

**THE END**

# WRITE Now! Comics School
## MINI-LESSON

# Comics and the Internet

## by Danny Fingeroth

In case you hadn't noticed, the Internet has changed some aspect of just about everything in modern life, from the way we interact with others to the way we shop—to the way we consume information and entertainment, comics prominently included. The Internet gives everybody with access to a computer and minimal technical skills (or at least a friend who has such skills) the ability to get their work "out there." But what does that mean, exactly? When everyone can "publish," how do you get people to make the effort and spend the time to see your work? And how do you make any income, much less a decent living doing that?

A lot of you reading this are no doubt wrestling with those questions and issues. The answers—and the questions, for that matter—change on an almost daily basis. Here are some general observations about comics and the Internet. (You can find specific sites to check out in the "Resources" section of this book.)

### The Internet as a showcase or virtual portfolio:

At the very least, you can put a resume and samples of your work on a website. It's a handy and convenient way for people to see your work and decide if they want to make contact for any reason.

### The Internet as a place to get paid for showing your work:

Yes, there are places where you can get paid for having your work shown at an aggregator of virtual comics. The money you make is usually based on how many "eyeballs" you bring to the site. For many creators, ironically, the home run is still publishing print versions of their comics as books. Hopefully, the people who loved your work online will hear about the print version from the web and feel the need to own a collected set.

### The Internet as a place to find a print publisher for your work:

Most publishers have websites that tell you how to submit work to them. Needless to say, the top editorial people don't have a lot of time to spend looking through the "virtual slush pile." But some do look, from time to time, and many companies have some staffer whose job it is to winnow the submission wheat from chaff. And, if you are able to create online buzz about yourself and your work, then publishers may come seeking you out.

### The Internet as a community:

You can be a participant or "lurker" on message boards and chat sites. You can certainly find a zillion news sites on whatever aspect of comics you're interested in. Just be careful that you don't mistake rumor for fact. And most importantly for someone who wants to build a body of creative work: don't be seduced into spending hours online when you could be (and should be) writing or drawing. People in creative fields can always rationalize time spent socializing (online or off), finding out the latest industry news, or playing games or cartoons, as "research" or "keeping up with the competition." A certain amount of that is fine and necessary. But you know when you're just procrastinating or goofing off.

### The Internet as a place to find creative collaborators:

There are some excellent sites where people can find other people to help with their projects. The caveat is the same here as in everything else on the net: people can say anything they want about themselves and their abilities. Use the same precautions meeting collaborators online as you would finding a date.

### The Internet as a place to study:

There's an explosion of Internet study available. The Kubert School and The Center for Cartoon Studies are two good ones. As far as other institutions or individuals, ask around and see which might be a good fit with your interests and goals.

**THE END**

Homepage of **Penny Arcade,** one of the most popular web comics sites. [http://www.penny-arcade.com/] [©1998-2006 Penny Arcade, Inc.]

# Appendix 2:

# Resources for Comics Creators

**F**or creators of comics—and anything else—everything is a potential resource as far as inspiration and subject matter. Even when getting down to concrete resources, there are countless numbers of them, especially when the World Wide Web can give you a dizzying array of choices.

Here are what we think are some worthwhile places, publications, and websites to check out. We make no pretense that this is a comprehensive list of anything. And, of course, websites can change in tone, content, or existence from day-to-day, so you go to them at your own risk. But those caveats aside, here are what we think are some pretty cool resources…

## COMICS-CENTRIC WEBSITES

### Museum of Comic and Cartoon Art
www.moccany.org
The museum of all things comics-related has regular shows (at their Manhattan headquarters and online) that shed light on important comics eras and creators. They also give classes in various aspects of comics, and their annual MoCCA Art festival is one of the major events for independent comics creators.

### The Grand Comic Book Database
www.comics.org
Contains information on comic book creator credits, story details, and other facts useful to the comic book reader and fan.

### TwoMorrows Publishing
www.twomorrows.com
Official site of the publishers of not only this book, but of *Write Now!*, *Draw!*, *The Jack Kirby Collector* and other fine comics-related publications.

### The Comics Reporter
www.comicsreporter.com
Tom Spurgeon's informative website is chock full of links to resources.

### Digital Webbing
www.digitalwebbing.com
Wide-ranging general interest comics site. A place to find collaborators to work with you on your comics site.
- Their talent search section is a good place to find collaborators for your comics: **www.digitalwebbing.com/talent**

### StickMan Graphics
stickmangraphics.com
Kevin Tinsley's guide to how to prepare your comic for printing.
- Kevin's invaluable list of resources, including comics printers: **www.stickmangraphics.com/resourceD.htm**

### Comicraft
www.comicraft.com/contact.html
Richard Starking's font of fonts and information.

Popular sources of news and opinion about the world of comics:
- newsarama.com
  **www.newsarama.com**
- The Pulse.com
  **www.comicon.com/pulse**
- Comic Book Resources
  **www.comicbookresources.com**

### Comicon.com
www.comicon.com
Links to comics conventions and creators.

### The Beat
www.comicon.com/thebeat
Heidi MacDonald's News Blog of Comics Culture.

### Permanent Damage:
www.comicbookresources.com/columns/index.cgi?column=pd
Steven Grant's insightful, sometimes controversial, CBR column about the comics scene and the larger world.

### Google Comic Creators Resources
www.google.com/Top/Arts/Comics/Resources/Creating/
Lots of cool comics stuff.

# WRITING WEBSITES

### Media Bistro
www.mediabistro.com
A New York based virtual networking site for writers, editors, and publishers. A good source of tips on how to pitch specific publications and keeping tabs on editors' whereabouts.

### Writer's Digest
Excellent magazine about all things writerly. Their website is equally valuable:
www.writersdigest.com

### Absolute Write
www.absolutewrite.com
All sorts of information for writers at all levels and in all media.

### Writers Gazette
www.writersgazette.com
An online community for readers and writers of all ages and interests.

### Google Writers Resources
www.google.com/Top/Arts/Writers_Resources/
Lots of cool stuff.

# ART WEBSITES

### Art Lessons by Bob McLeod
www.bobmcleod.com/lessons.html
Respected pro McLeod offers you guidance in how to draw comics.

### Mister Art
www.misterart.com
An online store that offers an amazing array of art supplies at decent prices.

### Free Foto
www.freefoto.com/
Tons of FREE photos for reference.

### History Place
www.historyplace.com
Site for historical art reference.

# EDUCATIONAL RESOURCES

### The Joe Kubert School of Cartoon and Graphic Art
www.kubertsworld.com/kubertschool/KubertSchool.htm
Comics giant Kubert's 3-year residential school specializing in the development of professional cartoonists and artists.

- Their **correspondence courses** are offered at: www.kubertsworld.com/

### The Center for Cartoon Studies
www.cartoonstudies.org/
James Sturm's school offers a two-year course of study that centers on the creation and dissemination of comics, graphic novels and other manifestations of the visual narrative.

### The National Association of Comics Art Educators.
www.teachingcomics.org/
Website of the organization committed to helping facilitate the teaching of comics in higher education. Lots of great links and resources for writers and artists here.

# BOOKS

### Story
*Robert McKee*
An excellent guide to story structure in any medium. His weekend seminars are worthwhile, too.

### How to Write for Animation
*Jeffery Scott*
Excellent bare-bones structural approach to animation writing, with many lessons applicable to comics.

### The DC Comics Guide to Writing Comics
*Dennis O'Neil*
The Dean of Comics Writers speaks. You should listen.

### The DC Comics Guide to Penciling Comics
*Klaus Janson*
Janson shows how to visually tell a story, which makes this a great resource for comics writers, too.

### Comics and Sequential Art & Graphic Storytelling
*Will Eisner*
Two books from the master of the medium that lay out the way to write and draw comics.

### Understanding Comics
*Scott McCloud*
A fun yet insightful look into how and why comics work.

### The Writer's Journey
*Christopher Vogler*
Another useful approach to understanding story structure.

### How To Draw Comics the Marvel Way
*Stan Lee & John Buscema*
Stan and John show you how it's done.

### Panel One: Comics Book Scripts by Top Writers
### & Panel Two: More Comic Book Scripts by Top Writers
*Nat Gertler* (editor)
Two books that give samples of the many different approaches to comics scripting, including samples from well known writers and artists, including Neil Gaiman, Peter David, Kevin Smith, and Marv Wolfman.

### Figure Drawing For All It's Worth
*Andrew Loomis*
Out-of-print, but worth the search.

### Comics Writers on Comics Scripting, vol.1
### (interviews by Mark Salisbury)
### & Comics Writers on Comics Scripting vol. 2
### (interviews by Andre Kardon and Tom Root)
What it sounds like. Lots of interesting information.

### The Complete Idiot's Guide to
### Creating a Graphic Novel
*Nat Gertler* and *Steve Lieber*
A comprehensive overview of how to make and how to make a living in mainstream and independent comics.

### The Making of a Graphic Novel
*Prentis Rollins*
Rollins tells how to create a graphic novel—and then shows the results in his **Resonator** GN, which is printed in its entirety in the book.

### Alan Moore's Writing For Comics Volume 1
*Alan Moore*
Moore on writing. 'Nuff said.

### Drawing the Head and Figure
*Jack Hamm*
A great book with a lot of information on structure, proportion, anatomy, and drapery. Hamm also did a good basic book on animals (**How to Draw Animals**), which is still available.

### Bridgman's Complete Guide to Drawing from Life
*George B. Bridgman*
The bible of figure drawing by the legendary teacher at New York's Art Students League. Bridgman's system of drawing, known as "constructive anatomy," is especially helpful to students who seek to draw dynamic figures.

### Atlas of Human Anatomy for the Artist
*Stephen Rogers Peck*
Another great book Mike recommends to his students, it covers in depth the human machine. A great companion to the Bridgman book, as it is less stylized.

### Animation
*Preston Blair*
A great book that teaches the principles of gesture, construction and motion, suited to both comics and animation. A classic book that's been in print since the '40s, which every cartoonist should own.

### Perspective for Comic Book Artists
*David Chelsea*
What it sounds like. An excellent resource.

### Your Career in the Comics
*Lee Nordling*
All sorts of important info about the world of comic strips.

## BY THE AUTHORS OF HOW TO CREATE COMICS FROM SCRIPT TO PRINT:

### How to Draw Comics from
### Script to Print *DVD*
*Danny Fingeroth & Mike Manley*
A valuable companion to this book, with the art aspect emphasized, demonstrating how to perform the disciplines involved in creating a comic.

### Superman on the Couch: What Superheroes Really Tell Us About Ourselves and Our Society
*Danny Fingeroth*
A book that explores why people love super-heroes, and very useful if you're looking to write about super-characters.

### Write Now! Magazine
*Danny Fingeroth*, editor-in-chief
twomorrows.com/index.php?main_page=index&cPath=60
The source for much of the material in this book, **Write Now!** is considered the premier magazine about writing for comics, animation, and sci fi—and not just by us!

### Draw! Magazine
*Mike Manley*, editor-in-chief
twomorrows.com/index.php?main_page=index&cPath=59
The source for much of the material in this book, **Draw!** is light years ahead of any other publication when it comes to telling you the creative and business lowdown on drawing comics and cartoons.
• Mike's website is: www.actionplanet.com

**THE END**

# TITANS COMPANION

A comprehensive history of the **NEW TEEN TITANS**, with interviews and rare art by **MARV WOLFMAN, GEORGE PÉREZ, JOSÉ LUIS GARCÍA-LÓPEZ, LEN WEIN,** & others, a Silver Age section with **NEAL ADAMS, NICK CARDY, DICK GIORDANO,** & more, plus **CHRIS CLAREMONT** and **WALTER SIMONSON** on the X-MEN/ TEEN TITANS crossover, **TOM GRUMMETT, PHIL JIMENEZ** & **TERRY DODSON** on their '90s Titans work, a new cover by JIMENEZ, & intro by **GEOFF JOHNS!** Written by **GLEN CADIGAN.**

(224-page trade paperback) **$29 US**

# SECRETS IN THE SHADOWS: GENE COLAN

The ultimate retrospective on COLAN, with rare drawings, photos, and art from his nearly 60-year career, plus a comprehensive overview of Gene's glory days at Marvel Comics! **MARV WOLFMAN, DON MCGREGOR** and other writers share script samples and anecdotes of their Colan collaborations, while **TOM PALMER, STEVE LEIALOHA** and others show how they approached the daunting task of inking Colan's famously nuanced penciled pages! Plus there's a **NEW PORTFOLIO** of never-before-seen collaborations between Gene and such masters as **JOHN BYRNE, MICHAEL KALUTA** and **GEORGE PÉREZ,** and all-new artwork created specifically for this book by Gene! Available in Softcover and Deluxe Hardcover (limited to 1000 copies, with 16 extra black-and-white pages and 8 extra color pages)!

(168-page softcover) **$26 US**
(192-page trade hardcover) **$49 US**

# COMICS ABOVE GROUND
## SEE HOW YOUR FAVORITE ARTISTS MAKE A LIVING OUTSIDE COMICS

COMICS ABOVE GROUND features top comics pros discussing their inspirations and training, and how they apply it in "Mainstream Media," including Conceptual Illustration, Video Game Development, Children's Books, Novels, Design, Illustration, Fine Art, Storyboards, Animation, Movies & more! Written by **DURWIN TALON** (author of the top-selling **PANEL DISCUSSIONS**), this book features creators sharing their perspectives and their work in comics and their "other professions," with career overviews, never-before-seen art, and interviews! Featuring:

- **BRUCE TIMM**
- **BERNIE WRIGHTSON**
- **ADAM HUGHES**
- **LOUISE SIMONSON**
- **DAVE DORMAN**
- **GREG RUCKA & MORE!**

(168-page Trade Paperback) **$24 US**

# COMIC BOOKS & OTHER NECESSITIES OF LIFE
## WERTHAM WAS RIGHT!
## SUPERHEROES IN MY PANTS!

Each collects MARK EVANIER'S best essays and commentaries, plus new essays and illustrations by **SERGIO ARAGONÉS!**

(200-page Trade Paperbacks) **$17 US EACH**
**ALL THREE BOOKS: $34 US**

# THE DARK AGE

Documents the '80s and '90s era of comics, from **THE DARK KNIGHT RETURNS** and **WATCHMEN** to the "polybagged premium" craze, the **DEATH OF SUPERMAN,** renegade superheroes **SPAWN, PITT, BLOODSHOT, CYBERFORCE,** & more! Interviews with **TODD McFARLANE, DAVE GIBBONS, JIM LEE, KEVIN SMITH, ALEX ROSS, MIKE MIGNOLA, ERIK LARSEN, J. O'BARR, DAVID LAPHAM, JOE QUESADA, MIKE ALLRED** and others, plus a color section! Written by **MARK VOGER,** with photos by **KATHY VOGLESONG.**

(168-page trade paperback) **$24 US**

# JUSTICE LEAGUE COMPANION VOL. 1

A comprehensive examination of the Silver Age JLA written by **MICHAEL EURY** (author of the critically acclaimed **CAPTAIN ACTION** and co-author of **THE SUPERHERO BOOK**). It traces the JLA's development, history, imitators, and early fandom through vintage and all-new interviews with the series' creators, an issue-by-issue index of the JLA's 1960-1972 adventures, classic and never-before-published artwork, and other fun and fascinating features. Contributors include **DENNY O'NEIL, MURPHY ANDERSON, JOE GIELLA, MIKE FRIEDRICH, NEAL ADAMS, ALEX ROSS, CARMINE INFANTINO, NICK CARDY,** and many, many others. Plus: An exclusive interview with **STAN LEE,** who answers the question, "Did the JLA really inspire the creation of Marvel's Fantastic Four?" With an all-new cover by **BRUCE TIMM** (TV's Justice League Unlimited)!

(224-page trade paperback) **$29 US**

# ALTER EGO COLLECTION, VOL. 1

Collects the first two issues of **ALTER EGO,** plus 30 pages of **NEW MATERIAL!** JLA Jam Cover by **KUBERT, PÉREZ, GIORDANO, TUSKA, CARDY, FRADON, & GIELLA,** new sections featuring scarce art by **GIL KANE, WILL EISNER, CARMINE INFANTINO, MIKE SEKOWSKY, MURPHY ANDERSON, DICK DILLIN,** & more!

(192-page trade paperback) **$26 US**

# AGAINST THE GRAIN: MAD ARTIST WALLACE WOOD

The definitive biographical memoir on one of comics' finest artists, 20 years in the making! Former associate **BHOB STEWART** traces Wood's life and career, with contributions from many artists and writers who knew Wood personally, making this remarkable compendium of art, insights and critical commentary! From childhood drawings & early samples to nearly endless comics pages (many unpublished), this is the most stunning display of Wood art ever assembled! **BILL PEARSON,** executor of the Wood Estate, contributed rare drawings from Wood's own files, while art collector **ROGER HILL** provides a wealth of obscure, previously unpublished Wood drawings and paintings.

(336-Page Trade Paperback) **$44 US**

# HOW TO DRAW COMICS FROM SCRIPT TO PRINT DVD

See a comic created from scratch, as the editors of **DRAW!** and **WRITE NOW!** magazines create a new character, step-by-step before your eyes, and produce a finished comic book from script to roughs, pencils, inks, and coloring— even lettering! It's 120 minutes of "how-to" tips, tricks, and tools of the pros, plus **BONUS FEATURES!**

(120-minute DVD) **$35 US**

# TRUE BRIT
## CELEBRATING GREAT COMIC BOOK ARTISTS OF THE UK

A celebration of the rich history of British Comics Artists and their influence on the US with in-depth interviews and art by:

- **BRIAN BOLLAND**
- **ALAN DAVIS**
- **DAVE GIBBONS**
- **BRYAN HITCH**
- **DAVID LLOYD**
- **DAVE MCKEAN**
- **KEVIN O'NEILL**
- **BARRY WINDSOR-SMITH** and other gents!

(204-page Trade Paperback with COLOR SECTION) **$26 US**

**CALL, WRITE, OR E-MAIL FOR A FREE COLOR CATALOG!**

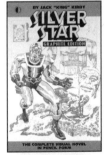

# COLLECTED JACK KIRBY COLLECTOR, VOLUMES 1-5

See what thousands of comics fans, professionals, and historians have discovered: The King lives on in the pages of **THE JACK KIRBY COLLECTOR!** These colossal **TRADE PAPERBACKS** reprint the first 22 sold-out issues of the magazine for Kirby fans!

- **VOLUME 1:** Reprints TJKC #1-9 (including the Fourth World and Fantastic Four theme issues), plus over 30 pieces of Kirby art never before published in TJKC! • (240 pages) **$29 US**

- **VOLUME 2:** Reprints TJKC #10-12 (the Humor, Hollywood, and International theme issues), and includes a new special section detailing a fan's private tour of the Kirbys' remarkable home,

showcasing more than 30 pieces of Kirby art never before published in TJKC! • (160 pages) **$22 US**

- **VOLUME 3:** Reprints TJKC #13-15 (the Horror, Thor, and Sci-Fi theme issues), plus 30 new pieces of Kirby art! • (176 pages) **$24 US**

- **VOLUME 4:** Reprints TJKC #16-19 (the Tough Guys, DC, Marvel, and Art theme issues), plus more than 30 pieces of Kirby art never before published in TJKC! • (240 pages) **$29 US**

- **VOLUME 5:** Reprints TJKC #20-22 (the Women, Wacky, and Villains theme issues), plus more than 30 pieces of Kirby art never before published in TJKC! • (224 pages) **$29 US**

# KIRBY UNLEASHED

The fabled 1971 **KIRBY UNLEASHED** portfolio, **COMPLETELY REMASTERED!** Spotlights **JACK "KING" KIRBY'S** finest art from all eras of his career, including 1930s pencil work, unused strips, illustrated World War II letters, 1950s pages, unpublished **1960s MARVEL PENCIL PAGES AND SKETCHES,** and **FOURTH WORLD PENCIL ART** (done expressly for this portfolio in 1970)! Kirby assistants **MARK EVANIER** and **STEVE SHERMAN** have updated the Kirby biography from the original printing, and added a **NEW FOREWORD** explaining how this portfolio came to be! **PLUS:** We've recolored the original color plates, and added **EIGHT NEW BLACK-&-WHITE PAGES,** plus **EIGHT NEW COLOR PAGES,** including Jack's four **GODS POSTERS** (released separately in 1972), and **FOUR ADDITIONAL KIRBY COLOR PIECES,** all at tabloid size!

(60-page Tabloid) **$24 US**

# SILVER STAR: GRAPHITE EDITION

**KIRBY'S** six-issue "Visual Novel" for Pacific Comics is reproduced from his powerful, uninked pencil art! Includes Kirby's illustrated movie screenplay, never-seen sketches, pin-ups, and more from his final series!

(160 pages) **$24 US**